Master Strokes
Pastel

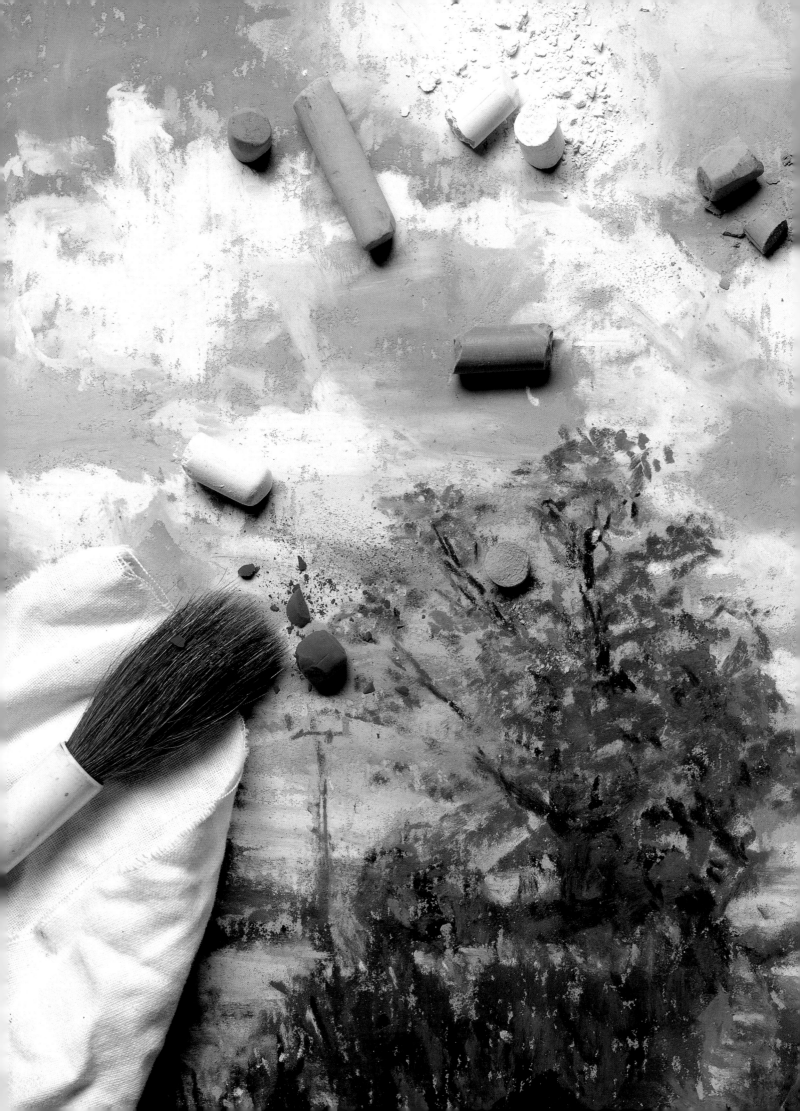

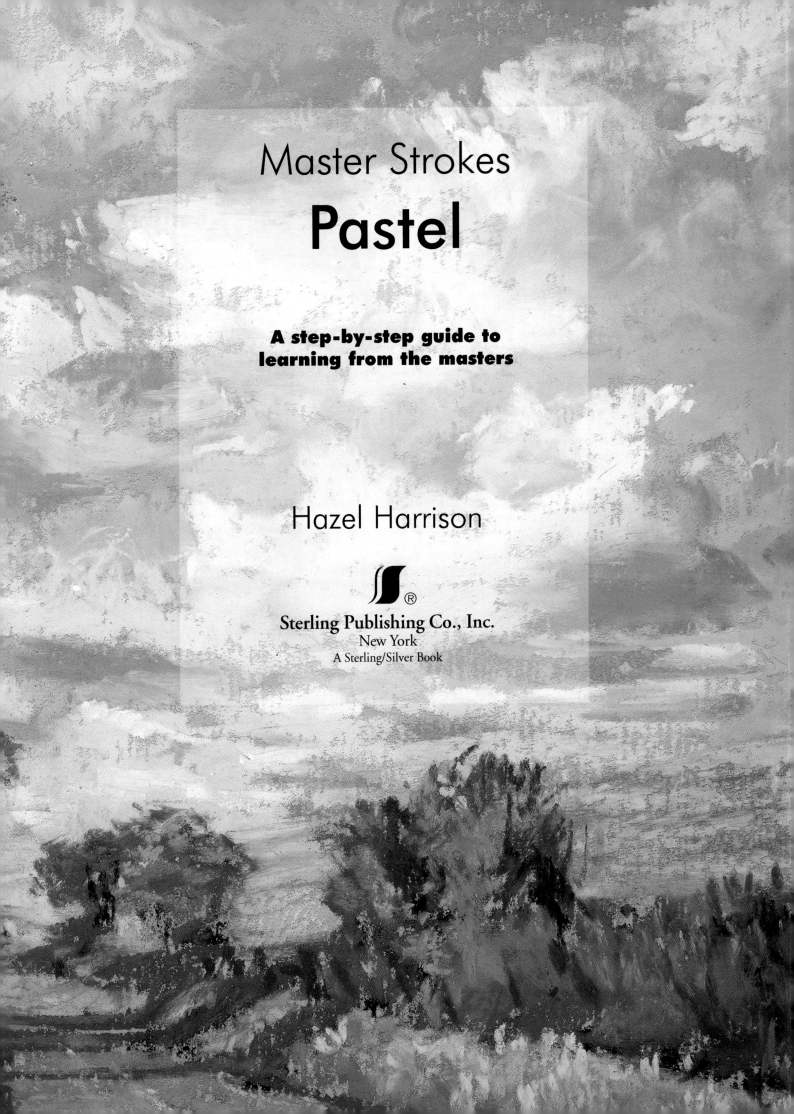

Master Strokes
Pastel

**A step-by-step guide to
learning from the masters**

Hazel Harrison

Sterling Publishing Co., Inc.
New York
A Sterling/Silver Book

Contents

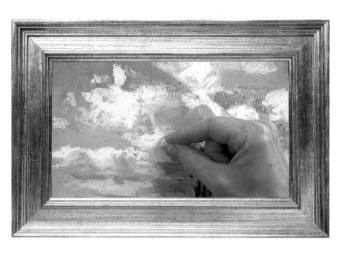

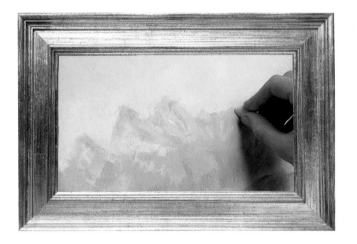

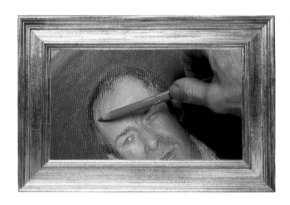

A QUARTO BOOK

Library of Congress Cataloging-in-
Publication-Data
Harrison, Hazel
 Master strokes. Pastels : a step-by-step
guide to using the techniques of the masters
/ Hazel Harrison
 p. cm.
 "A Quarto book"
 Includes index.
 ISBN 0-8069-2425-X
 1. Pastel drawing—Technique. I. Title. II.
Title: Pastels.
 NC880.354 1999
 741.2'35—dc21 98-46792
 CIP

10 9 8 7 6 5 4 3 2 1

ISBN 0-8069-2425-X

Published in 1999 by Sterling Publishing Co.,
Inc.
387 Park Avenue South
New York, NY 10016-8810

Copyright © 1999 Quarto Inc.
Distributed in Canada by Sterling Publishing
c/o Canadian Manda Group
One Atlantic Avenue, Suite 105
Toronto, Ontario, Canada M6K 3E7

This book was designed and produced by
Quarto Publishing plc
The Old Brewery
6 Blundell Street
London N7 9BH

Senior editor Anna Watson
Text editor Ian Kearey
Art editor Sally Bond
Designer Tanya Devonshire-Jones
Photographers John Wyand, Les Weiss

Illustrators Alan Oliver, Jane Hughes, Pip
 Carpenter
Picture researcher Gill Metcalfe
Art director Moira Clinch
Assistant art director Penny Cobb
QUAR.MTB

Typeset in Great Britain by
 Central Southern Typesetters, Eastbourne
Manufactured in Singapore by
 Pica Colour Separation Overseas Pte. Ltd.
Printed in Singapore by Star Standard
 Industries (Pte.) Ltd.

Urban landscape

The nude in context

Painting personal objects

Painting fruit

Pastel Techniques　74

Introduction

The aim of this book is to teach you how to analyze the works of the great masters, thus gaining knowledge and insights that will help you in your work.

HOW THE BOOK WORKS

The core of this book is the central section, which focuses in detail on a series of master paintings, each chosen to illustrate a specific subject area, such as portraiture, figure painting, or landscape. The analysis of each master painting is followed by a tutorial, in which a contemporary pastellist demonstrates how he or she treats a similar subject.

The teaching points gleaned from the master paintings and tutorials are cross-refered to the final section of the book, which explains individual pastel techniques, each

one illustrated with step-by-step demonstrations. The brief history of the pastel medium and practical advice on papers and equipment at the start of the book provide a useful introduction to the medium and its qualities.

"LEARNING FROM THE MASTERS" SECTION

The master paintings are looked at in detail over four pages, with captions and annotation explaining uses of color, composition and techniques. Certain sections of the works are shown in close-up detail to enable you to see the artist's methods clearly.

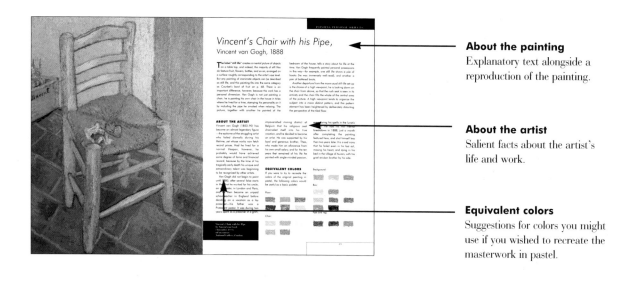

About the painting
Explanatory text alongside a reproduction of the painting.

About the artist
Salient facts about the artist's life and work.

Equivalent colors
Suggestions for colors you might use if you wished to recreate the masterwork in pastel.

Points to watch
Tips on how to approach the subject matter, and suggestions for overcoming common difficulties.

Focus on color
A teaching module varied according to the masterwork. In some cases the focus is on composition or technique.

THE TUTORIALS

A contemporary pastel painter shows how the lessons learned from the masterworks can be adapted and used in a individual way.

Introduction
Paragraph explaining the artist's way of working and, where relevant, the materials used.

Colors used
The artist's palette, giving you ideas on which colors to choose for a similar subject.

Step-by-step sequences
Shows how the painting is built up, from the planning stage to completion.

The finished picture
Large color reproduction with caption and annotation.

Techniques used
Refers you to the Pastel Techniques section, where you can find additional information.

Extra teaching points
Leader lines help you to focus on specific points of interest.

"PASTEL TECHNIQUES" SECTION

All the basic techniques used by pastel painters today, plus some more unusual ones you may like to try out. Combines with the lessons learned from the masterworks to provide a complete painting course.

Gallery paintings
A selection of finished paintings featuring specific techniques.

CONCLUSION

Studying the work of the masters is a productive exercise, as it helps you to bring the all-important element of analysis to your own work. Even though some of the masterworks shown here are in oil, and your chosen medium is pastel, the basic tenets of painting are the same whatever the medium used, and the essential lessons you learn from this book will help you to develop your art.

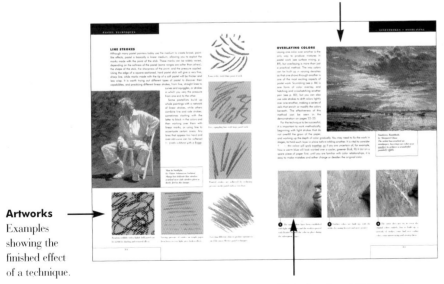

Artworks
Examples showing the finished effect of a technique.

Step-by-step sequences
Full-color demonstrations showing techniques in action.

Pastel
The Medium

PASTELS: A brief history

Pastels as we know them today—sticks of soft, crumbly color—have a relatively short history; you may have a vain search in an art gallery to find examples of an "old master" pastel.

The idea of producing a dry painting medium by binding pigment with gum is credited to an artist called Jean Perréal, who is almost unknown today but had a considerable reputation in his lifetime. Perréal accompanied the French king, Louis XII, on his Italian campaigns of 1502 and 1509, and while in Italy he met Leonardo da Vinci, who was much impressed by the new coloring method and mentioned Perréal in his notebooks. Leonardo did not use pastel as a full-color painting medium, as we do today, but as a means of adding color accents to charcoal or red-chalk drawings.

Pastel continued to be used through the 16th and 17th centuries, mainly for portrait sketches, where the flesh tones were often enhanced by the use of a blue

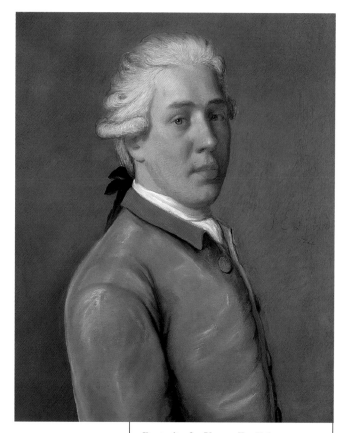

Portrait of a Young Englishman,
by Jeanne Etienne Liotard
Pastel on paper

On the Porch,
by Lydia Martin
Soft pastel on paper

paper as background. But it was not until the 18th century that it became accepted as a medium to rival oil paint. This is almost entirely due to a Venetian woman artist, Rosalba Carriera, whose pastel portraits achieved such success that she quickly became in demand throughout Europe. In 1720 she visited Paris, where her influence was huge. Among the artists to whom she introduced the medium was Maurice-Quentin de la Tour, (see p. 34) who subsequently became the most sought-after artist of his day, and painted many of his famous contemporaries in pastel, including Madame de Pompadour. He was an exceptional portrait painter who exploited the medium to the full, pioneering a technique

Lavender Fields
by Lionel Aggett
Pastel on paper

of broad strokes that enabled him to work on a large scale—earlier pastel portraits had been quite small.

Another important figure in 18th-century pastel painting was the Swiss artist Jean Etienne Liotard, who did not restrict himself to portraiture but included ambitious figure groups, genre scenes, and still lifes in his pastel repertoire.

Changing styles and subjects

With the exception of Liotard, the use of pastel was confined almost entirely to portraits, in which the notable characteristics are soft blends of color and a high degree of finish, in line with the then-fashionable style in oil painting. It was not until Edgar Degas began to work in pastels that we see the emergence of a "modern" style, in which the individual marks of the pastel sticks are encouraged to show rather than being rubbed together and blended.

Many artists tried their hands at pastels in the 19th century, including Eugène Delacroix, the landscape painter Eugène Boudin, and Edouard Manet, but Degas is by far the most important in the history of the medium. Always a technical innovator, he experimented with ways

of mixing the pastel with fluid mediums and using various home-made fixatives to set the colors so that he could build up in successive layers. He also pioneered the mixed-media approaches now common, often using pastel colors over his ink monoprints.

Degas saw himself as a draftsman above all else, and he used pastel in a way that combined drawing and painting. This had not been done before; the 18th-century artists used the medium more or less as a substitute for paint, taking care to obliterate the drawing, or mark-making, element, which they regarded as a weakness in technique.

Nowadays, most pastel painters would agree that one of the medium's many virtues is the ability it gives to combine color and mark-making so that drawing and painting come together as one. There are a large number of artists working in pastel today in all fields of painting, and a commensurate number of different styles. There are those who like to achieve a high finish, with imperceptible gradations of color and tone, but the majority regard visible pastel strokes as an integral part of their compositions, to be used both descriptively and expressively, like brushwork in oil painting.

Types of Pastel

Using soft (or chalk) pastels is almost like putting on neat pigment with your fingers, because pigment is more or less all they are—pigment held together with a weak solution of gum tragacanth. Most pastels also contain a preservative, and sometimes a fungicide.

There are different types of chalk pastel, some being harder than others, with a higher gum content. The softest pastels usually come as round sticks, the size depending on the manufacturer, although a range of cigar-shaped soft pastels has come onto the market recently.

Hard pastels, which are the same consistency as Conté crayons (and are sometimes given this name), are square-sectioned. They are more often used for drawings than for full-color paintings, but they can also be combined with soft pastels, and are useful for touches of fine linear detail. Pastel pencils, harder than soft pastels but softer than most hard pastels, are useful for small details, and to make underdrawings (see p. 91) where required.

All of the chalk-type pastels are compatible with one another. Hard pastels are sometimes used for the initial blocking-in stage of a work to be completed in soft pastel. The reason for this is that they are less easily brushed off the paper than the powdery, soft pastels, thus providing a relatively firm underlayer on which to build the work.

Color ranges

The main differences between pastels and paints is that you cannot premix colors; any mixing is done by laying one color over another on the painting surface (see p. 85). To compensate for this limitation, manufacturers produce large ranges of colors and "tints," i.e. light and dark versions of the same color. Tints

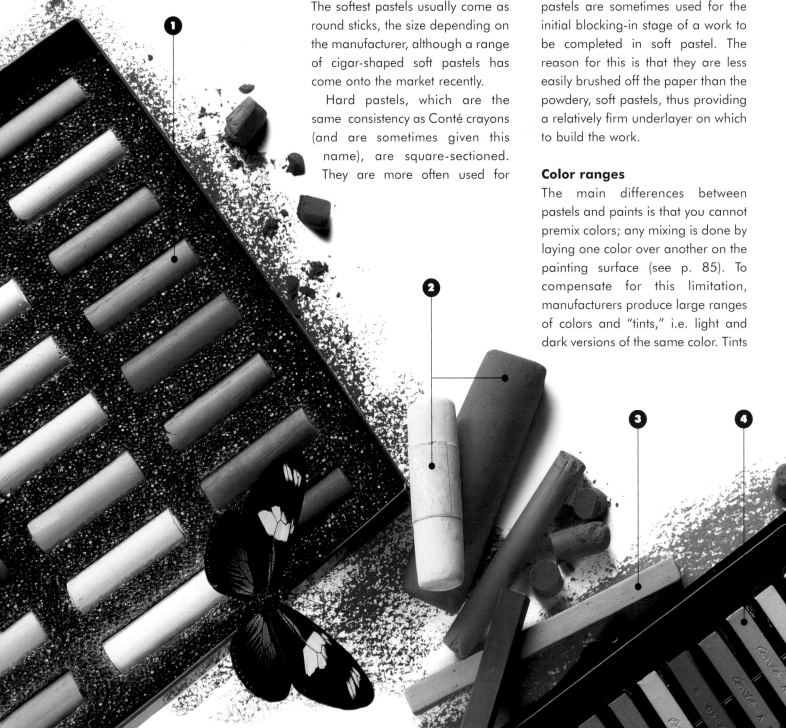

are made by adding white to the pure pigment for the pale tones and black for the dark ones.

The colors are given names that usually, but not always, correspond with the pigment name. Certain pigments cannot be used for pastels because they may pose a health risk, so you may find a red labeled "bright red" rather than vermilion or cadmium red. The tints are usually denoted by a number, from 1 to 6 or more. Manufacturers' numbering systems vary, but in most cases the lower numbers are paler tints, with the darker tints at the top of the scale and the pure color in the middle.

Oil pastels

These pastels were invented in the 20th century, and are very different from chalk pastels. The two types are not compatible, because they have quite different properties. Oil pastels are made from pigment bound with waxes and animal fat, and have a buttery consistency more like oil paint than chalk. They come in smaller color ranges than chalk pastels, but can be mixed on the painting surface by overlaying in the same way, or by "melting" the

color with turpentine or mineral spirits (white spirit) and spreading it out like paint. You can apply oil pastel with a brush, first dipping the brush into the solvent and then wiping it over the pastel stick to release the color.

One great bonus of oil pastels is that they do not require fixing, because the color cannot be brushed off the surface or accidentally smudged while working. Conversely, a disadvantage of oil pastels is that you cannot apply layer upon layer of color, because the surface becomes clogged and too greasy to accept more color.

Oil pastels can be worked with a brush, using mineral spirits (white spirit) as a solvent.

CLEANING PASTELS

Pastel is not a medium for those who like to keep their hands clean. Maurice-Quentin de la Tour complained about the tendency of his "colored dust," as he called it, to spread everywhere, and certainly it would be most unwise to use pastel in a carpeted room. But we can wash our hands and use vacuum cleaners after a working session; a more annoying problem is that the dust from one color gets onto all the others in your pastel box, and soon they are all unrecognizable. You can avoid this to some extent by laying them out on beds of ground rice, which absorb some of the dust, but you may still need to clean them from time to time, again using ground rice, as shown here.

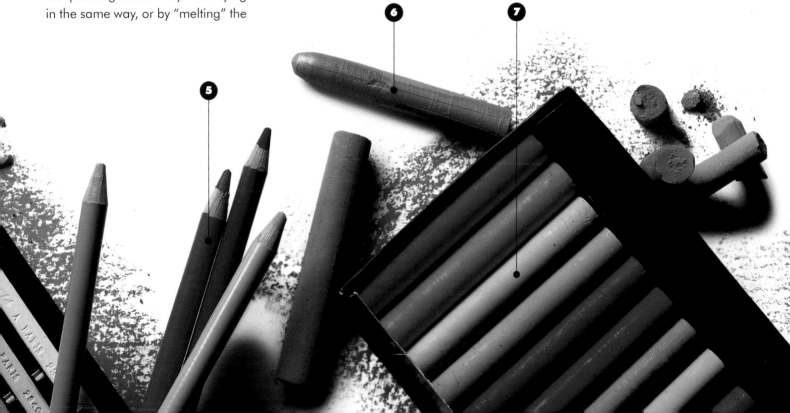

5

6

7

Surfaces for Pastel Work

Some of the pastel painters of the past worked on surfaces such as vellum or parchment, but today there are several papers especially made for soft-pastel work. The main requirement is a slight "tooth," or texture, to "bite" the pastel particles, holding them in place so that you can build up colors without overfilling the grain of the paper. The two papers shown, Mi-Teintes and Ingres paper, are both inexpensive and available from most art-supply stores.

Paper colors

Mi-Teintes and Ingres papers are made in a range of colors. Pastel is traditionally worked on a colored rather than a white surface, a practice that initially arose from the portrait "vignetting" technique, in which the face would be colored and the background left as the paper color. It is still quite usual to leave areas of the paper to stand as a color in its own right. In a landscape, blue-gray paper could be left largely untouched for the sky, or a contrasting color could be chosen, with small patches left showing to emphasize a dominant color in the painting. You will find more information on paper color in the Techniques section, under colored grounds (see p. 79).

MAKING A TEXTURED GROUND

Some pastel artists make and color their own grounds to individual recipes. One way you can do this is by scattering pumice powder on the surface of Masonite (hardboard) or heavy, smooth watercolor paper. You will need to lay a coat of adhesive on the board or paper first; this could either be glue size, wallpaper paste, or acrylic medium. When the surface has dried out, it can be colored with a wash of thinned acrylic.

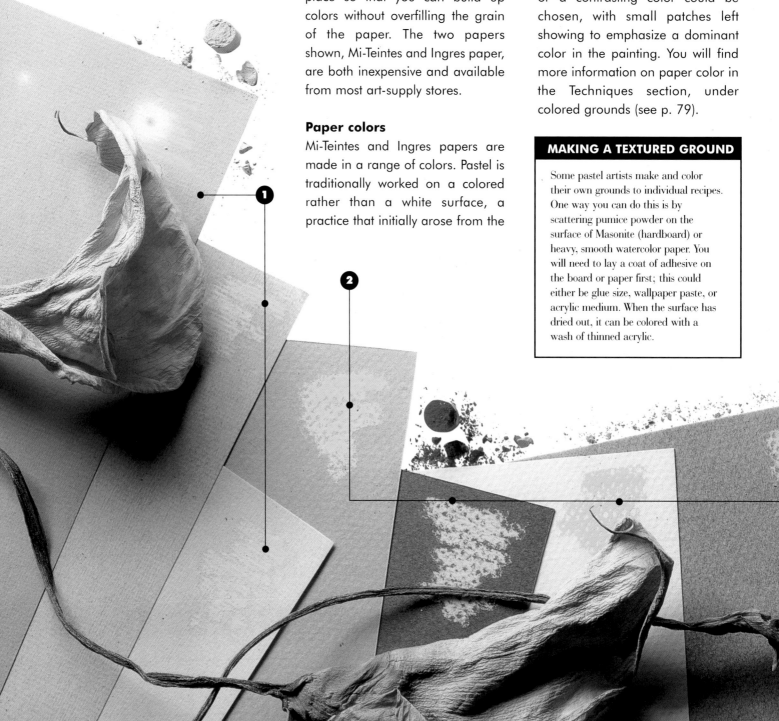

Other papers

Some pastel painters prefer a stronger texture than that provided by the two standard papers, and work on fine sandpaper. This is basically the same as the sandpaper sold for carpentry work, but made in large sizes especially for artists. A similar, but less scratchy, surface now becoming more widely available is pastel board (sometimes trade-named Rembrandt or Sansfix paper). Here, the surface is made from tiny particles of ground cork that hold the pastel so well that you do not normally require fixative.

Watercolor paper is another popular choice for pastels, favored especially by artists who like to work in pastel over a watercolor or acrylic underpainting (see p. 92). An advantage of watercolor paper is that you can lay a colored ground of your own choosing, simply by putting on a wash either of watercolor or of thinned acrylic.

Papers for oil pastel

Oil pastel will adhere to the surface very thoroughly, so you can use a smooth paper. However, this would only be suitable for a linear approach; if you intend to build up color in layers the surface would rapidly become clogged and unworkable, so a textured paper is a better choice. Both of the two standard pastel papers are suitable, as is watercolor paper, but sandpaper and pastel board are less sympathetic to this medium, and spreading the color with spirit could harm the surface. A good surface for a painterly use of oil pastels is oil sketching paper.

ADDITIONAL EQUIPMENT

There is little extra equipment required for pastel work, but you will certainly need fixative, plus some tissue paper or tracing paper for covering the finished work before putting it away in a portfolio. Some pastellists find rolled-paper stumps (torchons) useful for blending small areas, and some also like to use a maulstick (mahlstick) for steadying the hand (see page 81).

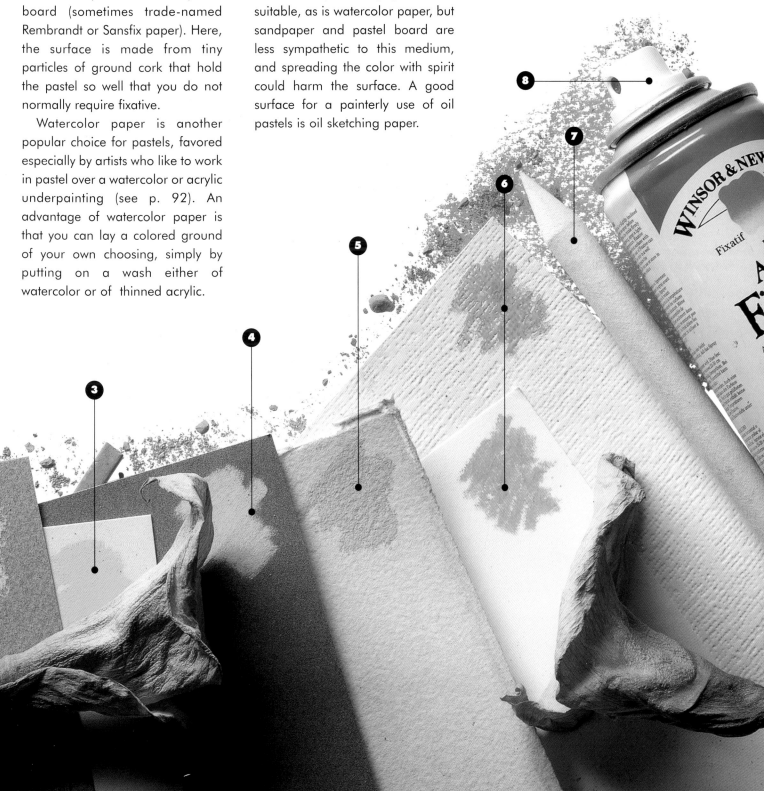

Pastel
Learning from the Masters

Norham Castle, Sunrise,

J. M. W. Turner, c. 1835–40

Norham Castle was a subject that Turner returned to several times over his long career. He had made a watercolor of it in 1797, and this, exhibited at London's Royal Academy, was so successful that he first included it in a book of engravings, and subsequently reworked it as an illustration for a book on English rivers. This later painting, however, is very different from the watercolor,

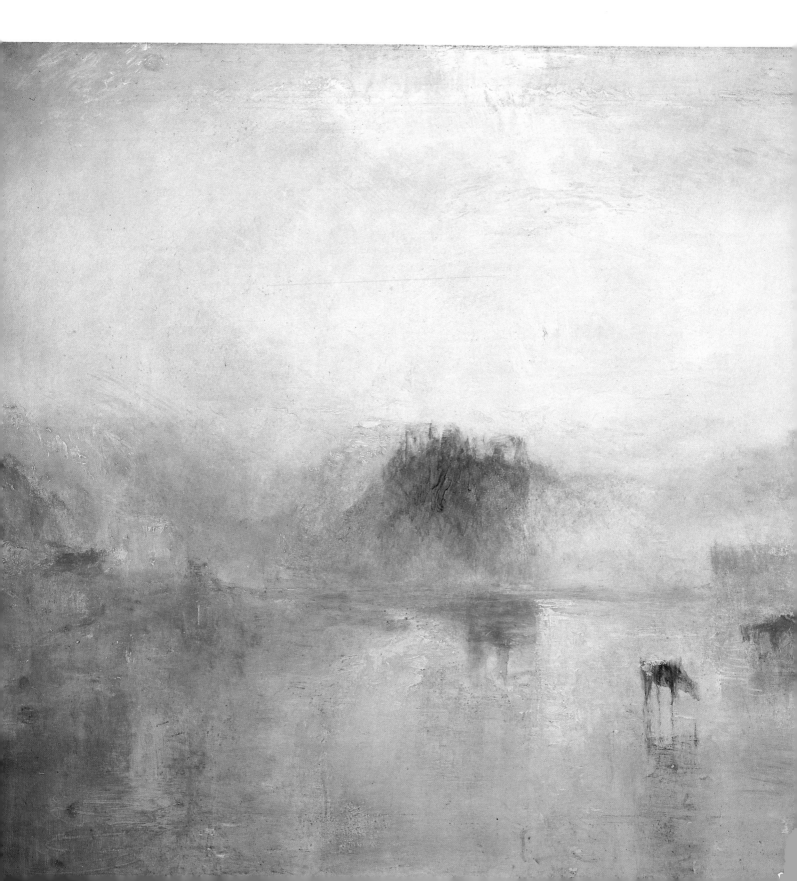

which, like many of his early watercolors, was made with the commercial market in mind. This was painted for his own satisfaction, was never exhibited, and is officially described as unfinished. It dates from a period in Turner's life when he was becoming increasingly fascinated by atmospheric effects in landscape, and experimenting with ways of conveying these in terms of pure color. The usual oil-painting practice at the time was to work on a mid-toned ocher ground, but Turner abandoned this in favor of white canvas, with the effect of heightening the tones by reflecting back through the thinly applied layers of color. This use of reflected white is basically a watercolor technique that Turner was able to adapt to oils through his mastery of both media.

*Norham Castle, Sunrise,
by J. M. W. Turner (c. 1835–40),
oil on canvas,
Clore Gallery, London.*

ABOUT THE ARTIST

Joseph Mallord William Turner (1775–1851) is recognized today as a genius, perhaps the greatest landscape painter in the entire history of art. His later works, with their dazzling technical innovations, have provided inspiration for many generations of artists, and continue to do so today, but they failed to please some contemporary critics, who dismissed them with phrases such as "whitewash and spinach." In spite of this, Turner had many enlightened patrons and admirers, and was highly successful in his lifetime. His background was humble, but his father, a London barber, was quick to notice his son's talent, encouraged him to study watercolor, and later became his business manager. Turner's career began as a topographical artist, making accurate and precise drawings of landscapes and architectural subjects—these were later sold to engravers or became the basis for watercolors. He continued to use watercolor and oil hand in hand throughout his life, exhibiting his first oil painting at the Royal Academy in 1796, and continuing to show paintings annually. By the age of 30 he was making a more than adequate income, and was able to build his own gallery, where he showed his more controversial works. He died a rich man, leaving a bequest of about 300 paintings and thousands of drawings and paintings to the nation.

EQUIVALENT COLORS

If you were to try to recreate the colors of the original painting in pastel, the following colors would be useful as a basic palette:

Sky:

Castle and hills:

Cow and foreground:

POINTS TO WATCH

To create this kind of misty, atmospheric effect, it is essential to give as much thought to tone as you do to color. When you look at a landscape in bright sunlight you will see strong dark/light contrasts, but a diffused light like this evens out the tones; a monochrome photograph would record a series of mid-toned grays, with no black or white. Also the edges of any objects will be softer than they are in strong light, and shapes will look flatter, with little detail. There is always a danger that a misty scene may look flat and dull, so don't sacrifice color to strict authenticity. Instead, follow Turner's example, and use pure colors in a high tonal key.

Color gradations
The lovely, glowing effect of the sun coming up through the layers of mist is conveyed by the soft blends of color, where yellow gradually shades into blue-gray, with no perceptible boundaries. Pastel is especially well suited to these gentle gradations, because it is easy to rub one color into another.

Reducing detail
The castle is little more than a vague shape, but Turner has used very thin paint, letting it run down to form a small gully that suggests the edge of a wall—a technique borrowed from watercolor. In pastel, a similar effect could be obtained using a sharp edge of darker blue pastel over a blended mid-blue.

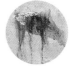

Giving a sense of scale
When featuring a large object as the focal point of landscape, such as this castle, or perhaps a group of imposing rocks or tall trees, the effect is more dramatic if you "explain" the size by comparison. The cows give this sense of scale, as would a figure, or group of figures. We are familiar with animals and people, and know their size, whereas we would not know the size of a castle or tree without seeing it.

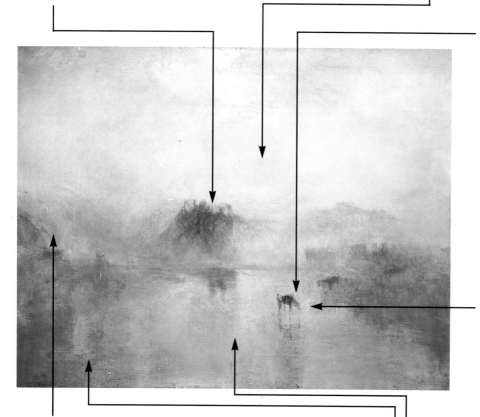

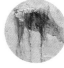

Minimum definition
The foreground cow is almost a flat shape, with the form of the body just hinted at by the direction of the brushstrokes. A touch of definition is provided by the downward strokes forming the legs, and a few touches of thick white paint on the animal's back.

Layering colors
The luminous color effects have been achieved by laying thin veils of color, called glazes, over a white ground. You cannot exactly imitate this effect in pastel, but you can come close to it by combining blending techniques (see p. 76) with broad, lightly applied side strokes laid over one another. You might also try working on white, rather than the more usual tinted paper.

Stressing the focal point
The castle is the focal point of the painting, but because it is such an amorphous, generalized shape, it needs some additional emphasis to draw the eye toward it. Turner has provided this through the bands of yellow reflection that lead up to it. The two areas of red on each side of the foreground also act as a frame for the blue shape.

FOCUS ON COLOR

Turner has expressed the quality of the light through the use of a limited range of colors in a high tonal key, that is, with no dark areas. By working with thin veils of semi-transparent color, he was able to use the white of the canvas as a positive element. The simple, but highly effective, color scheme is based on

the three primary colors: blue, red, and yellow. This almost certainly departed from the literal truth; a subject like this would probably have contained little pure color. Turner was criticized for inventing color and light effects, but we now appreciate the value of judicious invention, and heightening colors is relatively commonplace.

Color relationships (below)
In keeping with the misty, atmospheric effect, the red is not used at full strength, but is slightly muted, both in tone and in hue. But it appears intense because of its relationship with the surrounding colors—delicate pale-toned mauve-grays and creamy yellows.

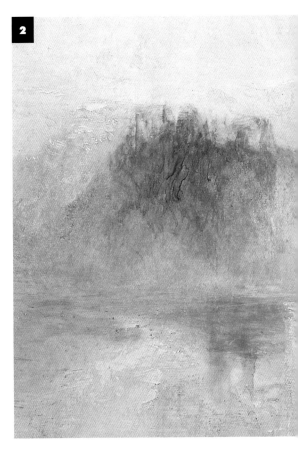

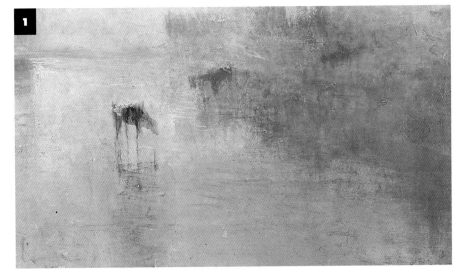

Primary contrast (above)
The contrast of colors and tones is strongest in this central area. Blue and yellow are opposites on the color wheel, and always set up vibrant effects. Also, blue is a naturally darker color than yellow, so there is a built-in element of tonal contrast.

Controlled tones and colors (right)
This detail shows how skillfully the tones and colors have been controlled, with just a whisper of darker tone separating the hill from the sky, and then the hill from the lines of trees beneath. All the secondary colors contain components of the three primaries—for example, there is a little red in the mixture for the hill, and the sky grades from muted yellow on the left to a warm blue-gray on the right. This gives the painting a complete unity of color that contributes to the brilliance of the overall effect.

TUTORIAL: Atmospheric Landscape

Pastel is the perfect medium for gentle, misty light effects. The only possible danger is that you may overblend to produce light tones and gentle gradations, or lose sight of color altogether and produce a picture in shades of pale gray. In "Lake View at Grand Teton National Park," Steven Bewsher takes a leaf out of Turner's book and works with vibrant colors in a range running from light to mid-tone. Although he blends colors in the early stages, the blends are overlaid with firm pastel strokes that give the painting an additional surface interest that in turn enhances the subject matter.

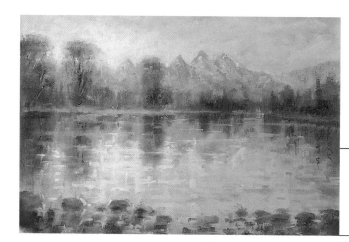

Lake View at Grand Teton National Park, by Steven Bewsher

COLORS USED

Because the names of pastel colors vary widely according to the manufacturer, we show the colors only as swatches. If you do not have these colors, most art-supply stores will offer a corresponding range.

Sky and water:

Mountains, trees and their reflections:

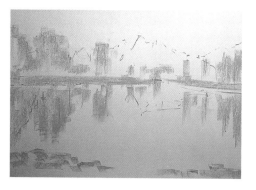

1 Drawing and blocking in (above)
The artist has chosen a light cream paper of roughly the same tone as the pale yellows he will use. After making a sketchy drawing in blue to place the main shapes, he begins to block in the central area of the composition, using sidestrokes of gray.

2 Planning the colors (above)
The grays have two purposes. First, they provide a tonal underdrawing, and second, they will help to mute the colors laid on top; this area is to be relatively neutral in color. No gray has been used on the sky, water, or mountains, because the colors for these must be pure and unsullied.

TECHNIQUES USED

Blending page 76
Details and edges page 81
Line strokes page 84
Side strokes page 88
Surface mixing page 89

3 The light source (left)

After working some brown earth color into the gray of the trees to define the shapes, the next important step is to establish the light source. To ensure that the sky and the water reflecting it are firmly linked, yellow is applied to both areas simultaneously.

4 Soft effects (right)

For the time being, the artist avoids hard edges and definition in the water; these will come later. Instead, he concentrates on covering the paper with light blue-gray and yellow, laying down light sidestrokes and rubbing them well into the grain with his finger.

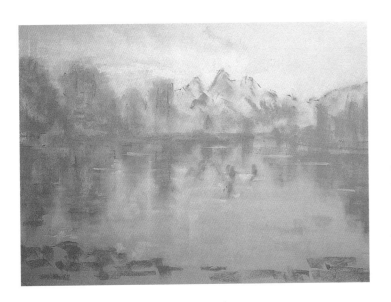

5 Stating the key colors (left)

The color scheme of the painting is based on the blue/orange and yellow/mauve complementary pairs, so these colors are established first, to act as a key against which to judge colors for the trees and foreground.

7 Working the color up (below)

The strategy behind the painting is to begin with faint whispers of color and work gradually up to the brighter hues. A vivid orange-yellow is taken around the outer edges of the trees, that catch the light of the setting sun.

6 Muted color (below)

The greens are to be played down so that they do not detract from the blue/yellow contrast, so a mid-toned gray-green is used, knocked back further by being applied over the original gray. It is important to have a good selection of these neutral colors for landscape painting.

8 Working over the whole painting (left)

So that the painting develops as a whole, the artist moves from area to area, bringing each one to the same stage of completion. He now adds touches of reflected sunlight to the top of the mountains. Notice how he uses the direction of the pastel strokes to define the shapes.

9 Definition (below)

The trees are left as soft-edged shapes, with tones and colors merging gently into one another, but a touch of crisp definition is needed to explain their structure. Trunks and branches are drawn in with the tip of a red-brown pastel, held lightly near the end so that lines do not become too heavy and uniform.

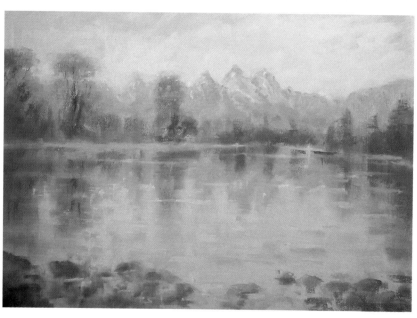

10 Preparing for finishing touches (above)

Deciding how much final detail to put in is one of the most problematic aspects of painting, so the artist views his work to consider the areas that need to be brought into sharper focus. At present, the focus is equal all over, so the foreground water clearly needs more work.

11 Varying the marks (left)

The main reflections in the center of the picture have been painted with broad, horizontal sidestrokes, but these tall, spiky trees on the right cast a stronger reflection, described with squiggling point strokes that suggest the broken surface of the water.

12 Relating sky and water (right)

Throughout, the artist has worked the sky and water together and, having made some small but important adjustments to the sky, he can add the final touches to the water. He creates the ripples by working strokes of yellow over the previous yellows and blues. The yellow chosen is paler and less assertive than that used for the sky, because reflected color is never as bright as the light source itself.

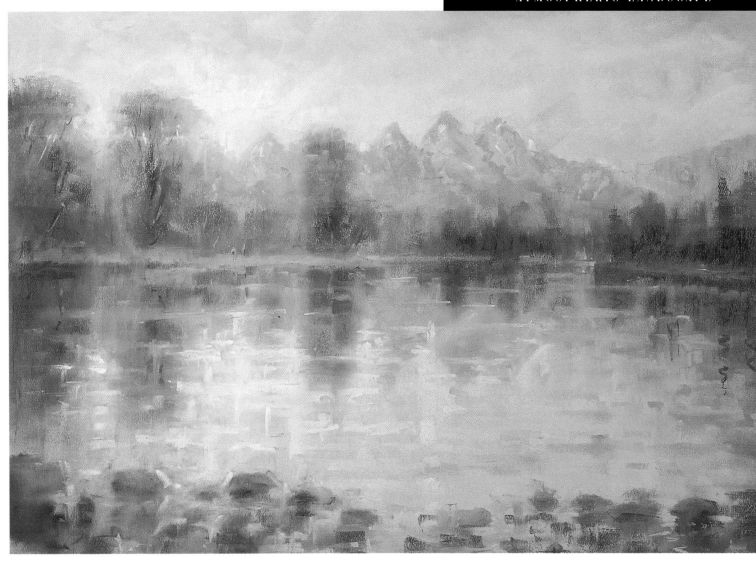

The finished picture is full of atmosphere, and has a lively sparkle, due not only to the brilliance of the colors but also to the skillful and sympathetic use of the medium.

Drawing with color
The shapes of the mountains are suggested by the way the pastel marks are used, with short sidestrokes varying in direction to follow the lines of the rocks. Point strokes pick out small sunlit patches.

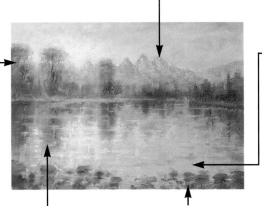

Colorful neutrals
In this area, you can see how the so-called neutral colors can also be vibrant. The range of mid-toned blue-grays, green-grays, and mauves used for the darker areas "sing" against the brilliant orange-yellow around the edges.

Judicious repetition
There is a good deal of variety in the strokes used over the whole painting, but in this area of foreground water, the shapes of the strokes repeat those of the stones, so that water and stones become a homogeneous area.

The surface of water
When painting reflections, it is important also to indicate the horizontal surface of the water. Here, horizontal and vertical strokes describe both dimensions.

Playing down the foreground
The foreground stones are equal in tone to the darker parts of the trees, and they are painted with little detail. If they had been treated more strongly, this foreground area would have acted as a block, preventing the viewer's eye from traveling inward to the far bank.

Weymouth Bay,
John Constable, c.1816

Constable was the first artist to fully realize the importance of skies in the composition of landscape paintings, and to treat them with such truth. Totally committed to the depiction of the English landscape, he was determined to see nature with his own eyes, rather than following a series of "recipes" laid down by previous masters. His practice was to make small, rapidly executed oil sketches, recording cloud formations and color effects under different conditions, thus amassing visual reference to be used in his large studio paintings exhibited at the Royal Academy, such as the well-known *Haywain* (he called these his "six-footers"). Today, his spontaneous

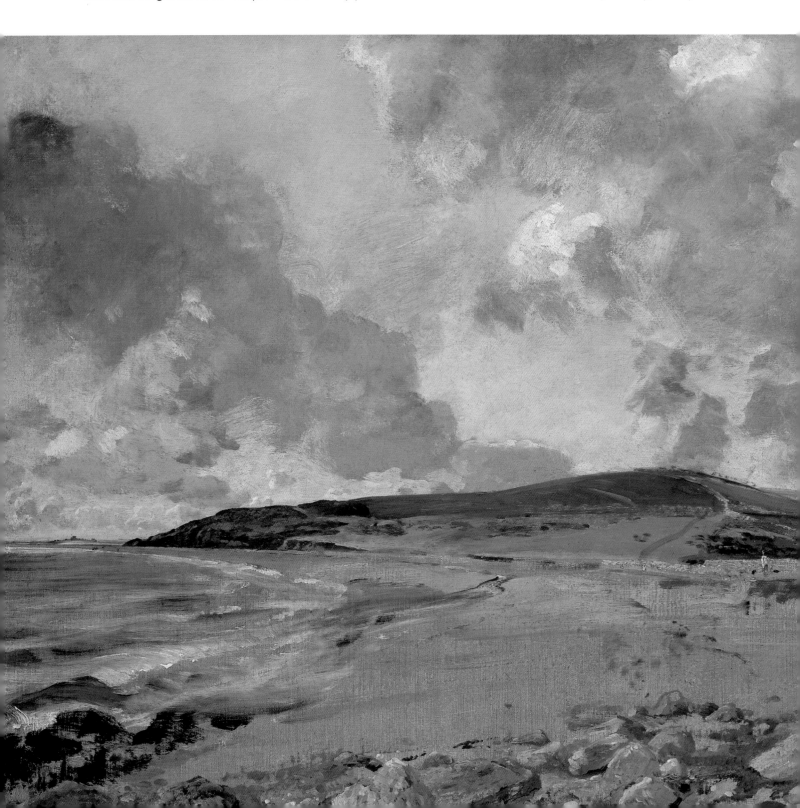

sketches, showing a direct link with the approach of the Impressionists, are more admired than the "worked-up" paintings demanded by the taste of the times. This work, demonstrating Constable's free, but assured, technique at its best, with the varied and decisive brushwork giving a strong sense of movement lacking from the studio paintings, was almost certainly painted direct from the subject, though this is not known for certain. It was painted rapidly, with areas of the ocher-brown ground left uncovered, and the clouds treated with great economy— a form of visual shorthand.

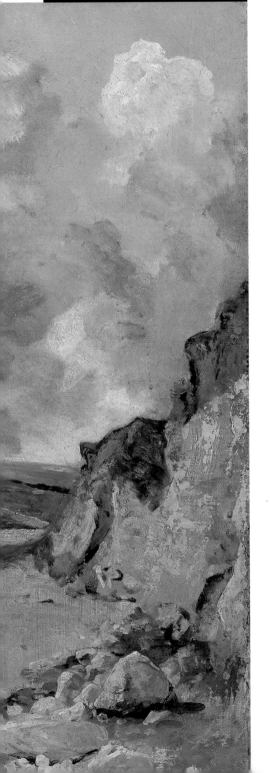

Weymouth Bay,
by John Constable (c. 1816)
Oil on canvas,
National Gallery, London.

ABOUT THE ARTIST

John Constable (1776–1837) was unusual for his times, in that he never left his native country. Not for him the grand splendor of the Alps, sought by many other contemporary painters, including Turner; Constable's enduring love was the English landscape: "The sound of water escaping from mill dams, willows, old rotten planks . . . I love such things. These scenes made me a painter."

He was the son of a prosperous mill owner in Suffolk, and although he showed an interest in painting from an early age, he did not fully adopt the profession until 1799, when he enrolled as a student at the Royal Academy. His early works were clumsy and, realizing their inadequacies, he started copying old masters to teach himself technique and composition. Gradually he began to combine lessons learned from past masters with his own observations, and well before 1821, when he painted *The Haywain*, he had found his own voice as an artist. In 1816 Constable's father died, leaving him financially secure and thus able to marry Maria Bicknell, whom he had courted for seven years, against the wishes of her family. They were a devoted couple, and he was deeply distressed by her death in 1828, his unhappiness little alleviated by his long-delayed election to the Royal Academy the following year. He had never been held in high regard by the English artistic establishment, and an auction of his paintings held after his death aroused little interest— most were bought by members of his family.

EQUIVALENT COLORS

If you were to try to recreate the colors of the original painting in pastel, the following colors would be useful as a basic palette:

Sky:

Sea and landscape:

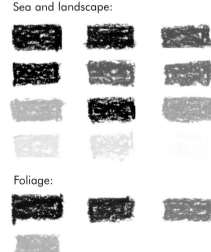

Foliage:

POINTS TO WATCH

One of the pitfalls in landscape painting is a failure to relate the sky to the land in terms of color. By working on a colored ground, and deliberately leaving parts of it uncovered in both areas of the painting, you will achieve a unity of color that will help the painting to hang together as a whole. Always look for ways of setting up these color echoes, perhaps introducing touches of the land color into the sky, and vice versa. Make sure also that your technique is consistent throughout the picture, and avoid treating one area in a tighter, more detailed manner than another.

Composition
Although rapidly painted, the composition is carefully planned and well-balanced. The strong shape of the rocks on the right acts as a counterpoint for the dark cloud at top right, and continues the curve of the foreground that sweeps around the picture from the left and inward toward the small figure in the distance.

Using the ground color
In parts of this sky area, the ground color has been left showing, to echo the beach and foreground stones, and at the top, further rich browns have been added over and into other colors.

Placing the horizon
When the sky forms an important part of the painting, as it does here, the obvious choice is to let it occupy a large part of the picture space. But do not overdo this, or the composition may suffer. Here the sky is given just under two-thirds of the picture space, a division that is aesthetically pleasing.

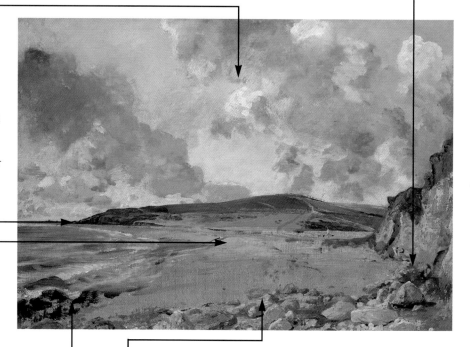

Limiting the color scheme
A good way of ensuring compositional unity is by using a limited palette of colors. The color scheme here is based on the contrast between yellow-brown and blue-gray, with the green of the hill providing a muted accent, light enough in tone to blend in with the beach and take its place in space.

Foregrounds
Objects in the immediate foreground can be a problem, because it is tempting to treat them in more detail than the rest of the painting, thus losing the coherence of the composition. Constable has made a visual link between the foreground and sky by repeating the same blue-grays in both areas, and by using the same kind of brushwork for both.

Balancing tones
These lightly sketched-in rocks are essential to the composition, because the dark tone balances that of the far end of the distant cliffs. They also make an elongated, roughly triangular shape that helps lead the eye into the picture along the curve of wet sand in the foreground.

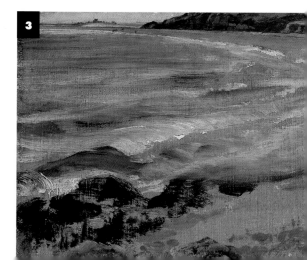

3

FOCUS ON TECHNIQUE

If you compare a photograph of a sky-dominated landscape with a painting such as this, or an Impressionist work, you can appreciate the importance of the artist's craft immediately. Photographs freeze the subject, making clouds appear solid and static, but as you can see from this painting, an artist is able to suggest the movement of the sky, and the way the clouds are constantly forming and re-forming, by the way he or she uses brushstrokes. You can do very much the same thing in pastel, by varying the direction and weight of the strokes, and using a sharp edge to add occasional touches of crisp definition. You can also avoid the risk of overworking by using the paper as a color in its own right, as Constable has done here.

Brushwork (below)
The variety of the brushwork is especially noticeable in this area, with some strokes curving around the cloud shapes, and others running in straight diagonals and counter-diagonals. The darker tones have been worked wet in wet over lighter colors so that the boundaries between tones are soft and blurred. For crisper effects, such as the edges where the white cloud on the right meets the blue sky, the paint has been used more thickly, the equivalent of a heavily applied pastel stroke.

Blended effects (below)
For the central area of dark cloud, the paint has been applied relatively thinly, with various grays and blue-grays blended into one another to create a homogenous passage of color. The ground color has been left showing through in places, to add a touch of warmth to the cool grays. Again, similar effects can be achieved when using pastel.

Ground color (below)
When painting on the spot, time is always a factor, and working on a colored ground cuts down painting time, because parts of it can be left alone, with no added color. Here, the ground has been left uncovered to represent the whole of the beach, with just a few light strokes and dabs of paint laid over it in strategic places. The stones in the immediate foreground are painted firmly, again with directional brushstrokes and strong tonal contrasts that bring the area forward in space.

Moving water (left)
As with skies, using a tight, over-controlled technique for moving water can destroy the feeling of movement, so take care not to overwork it. Constable has employed the same "shorthand" method as for the clouds, painting the sea with just a few long strokes crossing one another in places, and leaving much of the ground color showing. Gently curving strokes, made with thicker paint, follow the direction of the wave breaking on and drawing back from the sand, emphasizing the movement.

TUTORIAL: Painting Skies

There are many similarities between Margaret Glass's painting, "After a Spring Shower," and the Constable oil shown on the previous pages. As in the Constable, the sky, with its deep, rich colors and strong shapes, is a vital element in the composition, occupying well over half of the picture space, yet it is not over-dominant because the landscape features are treated equally firmly. Like Constable, the artist has set up both color and shape echoes between sky and land, and has also used the marks of the pastel sticks both descriptively and expressively. She is working on artist's sandpaper, which she likes because it allows her to build up the colors thickly.

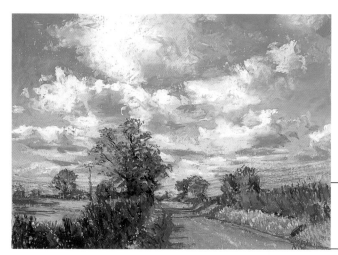

After a Spring Shower, by Margaret Glass

COLORS USED

Because the names of pastel colors vary widely according to the manufacturer, we show the colors only as swatches. If you do not have these colors, most art-supply stores will offer a corresponding range.

Sky and clouds:

Trees and fields:

1 Mapping out (right)
The blue of the sky is to be the dominant color, so the artist uses blue to map out the main elements in the composition—the shape of the cloud mass, the road and the large tree. She does not engage with any of the subsidiary features at this stage.

2 Establishing the darks (left)
It is important to consider the tonal balance of the composition from the outset, so before working on the mid-tone of the sky, she blocks in the dark areas of foreground, at the same time working out the composition and the placing of the horizon.

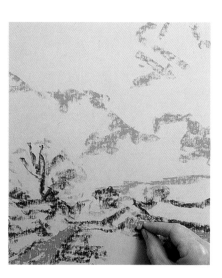

TECHNIQUES USED

Details and edges	page 81
Line strokes	page 84
Overlaying colors	page 85
Side strokes	page 88

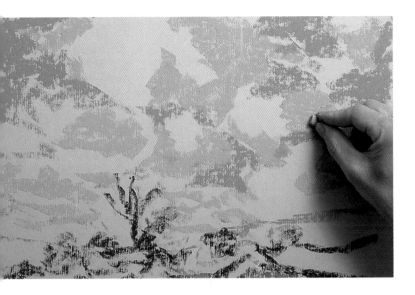

3 Warm and cool colors (left)

Now she begins to work on the sky, blocking in the shadowed undersides of the clouds with a cool green-gray and the areas of clear sky with warmer blues. Notice that the deepest and warmest blues are at the top of the sky, where the color is always strongest; it becomes paler and cooler above the horizon.

4 Building up the forms (below)

Rather than relying on tonal contrasts alone to build up the forms of the clouds, the artist juxtaposes and overlays warm and cool colors. Here she is laying a warm mauve-gray over the green-gray to bring the nearer part of the clouds forward and create visual perspective.

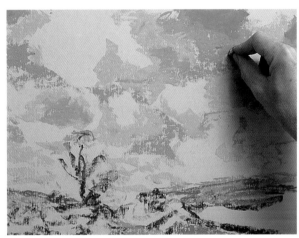

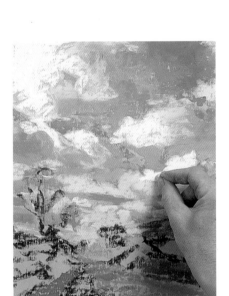

5 Keeping the colors pure (left)

With the darker areas of the clouds established, she can begin to build up the light tones, and uses a small piece of pastel to lay thick side strokes of white for the sunlit tops of the clouds. These areas of the paper were previously left uncovered so that the white is not sullied by earlier layers of color.

6 Avoiding overworking (below)

She continues to build up the forms of the clouds, letting the strokes of white blend into the blue slightly at the edges to create soft, vaporous effects. Although she uses the pastel thickly, she takes care not to overwork it, letting the marks of the pastel show and leaving small patches of the sand-colored paper uncovered.

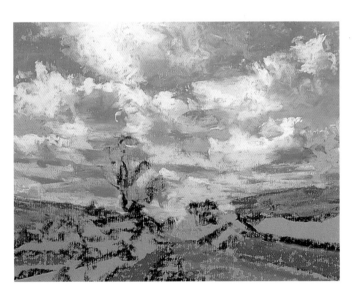

7 The painting strategy (above)

Because the sky plays such an important part in the composition, it has been completed first, providing a key against which to judge the colors and tones needed for the landscape. This method, of working from top to bottom of the painting, is also a practical one in pastel work, as it avoids the danger of accidental smudging.

31

8 Impasto effects (left)

This detail shows how thickly the pastel has been applied, emulating the impasto effect used by oil painters. The ridges of solid pigment catch the light, creating an almost three-dimensional effect. For this method to be successful, it is essential that the thick color is not touched after an area has been completed.

9 From dark to light (below)

Except for the sunlit fields near the horizon, the land area is mainly darker in tone than the sky, so the artist builds up these dark tones with a selection of deep browns and gray-greens. She works fairly lightly, avoiding over-filling the grain of the paper, so that she can overlay lighter, brighter colors in the final stages.

10 The importance of planning (below)

The artist has left the paper uncovered for the central part of the tree to ensure that the dark, rich browns she adds at this stage retain their integrity and do not mix with earlier colors. But at the edges of the tree, especially on the left, the dark colors are laid over the blues and grays, which softens them, thus giving depth of form to the shape.

11 Assessing the painting (left)

The painting is almost complete, and the artist stands back from it to decide on finishing touches. Some areas of the foreground need lifting to bring the area forward in space, and the trees are not yet fully three-dimensional.

12 Optical mixing (above)

The sunlit verges of the road provide an accent of brilliant color that carries through the theme of light and shade as well as bringing the area forward in space. Instead of using several ready-made greens, she juxtaposes orange, blue, yellow, and olive green, which mix optically to read as green.

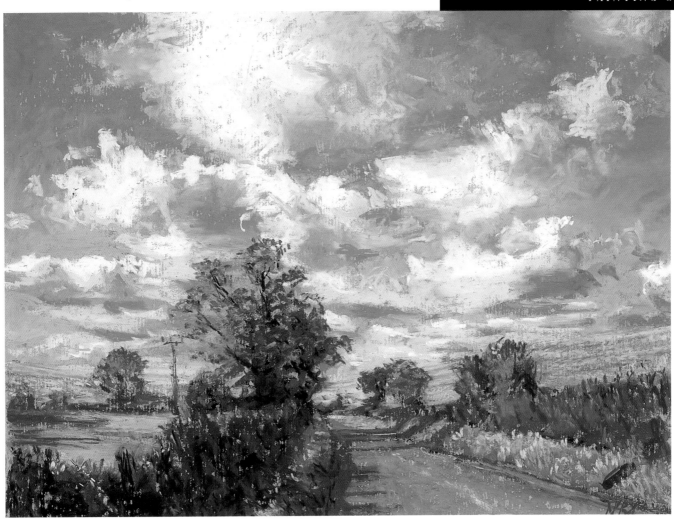

The finished painting is a lovely evocation of the English countryside, one that Constable himself would have admired. The medium has been handled with skill and sensitivity, and the composition is simple but effective.

Creating movement
Unless care is taken, clouds can very easily appear static and solid, but here the artist has given an impression of swirling movement by the way she has varied both the weight and the direction of her pastel marks.

Letting the paper show
The warm, sandy color of the paper contrasts with the blue of the sky, and small patches have been allowed to show at the edges of the clouds. This enhances the sunlit effect and also creates color links with the foreground and trees, where the same method has been used.

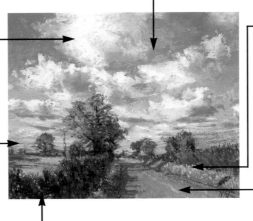

Descriptive strokes
The painting is a good example of the use of varied pastel marks. The sky is built up mainly with side strokes, but here sharp, short, linear strokes have been used to indicate the direction of growth.

Creating space
The spaciousness of the landscape has been beautifully conveyed through control of tone and color. For the most distant fields, which almost merge into the sky, cool, pale greens have been used, with the colors becoming progressively warmer toward the foreground.

Stippling
The small points of light here and on the trees were achieved by stippling with the point of the pastel in the final stages of the painting. Notice how the artist has varied the marks in shape, size, and direction to describe the foliage.

Color and composition
The road plays a role in both the color scheme and the composition. It leads the eye into the picture toward the large tree and then the distant fields, and because it reflects color from the sky, it provides a color link that ties the two areas together.

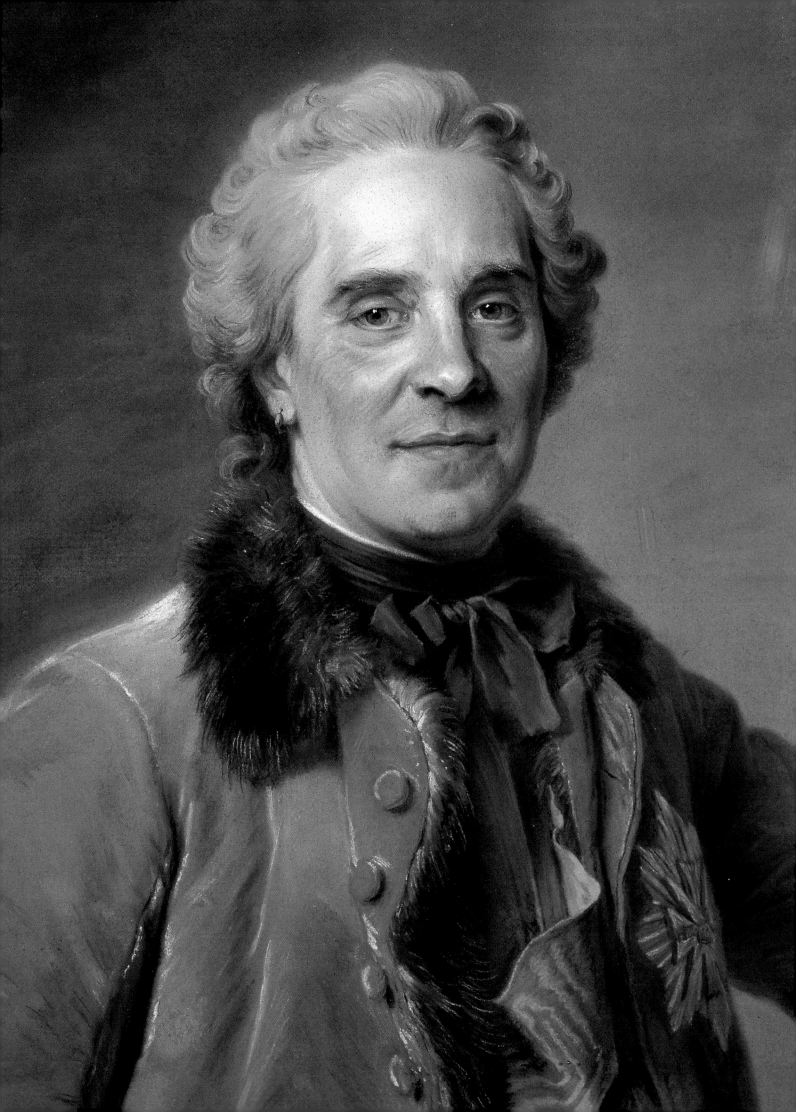

Hermann-Maurice, Maréchal de Saxe,

Maurice-Quentin de La Tour, 1748

This is one of several portraits by de La Tour of France's great military hero of the time, adored by the public, famed for his amorous exploits, and honored for his services to the country with the title of Marshall-General. He was keenly interested in art, and enjoyed the company of artists, spending much time in de La Tour's studio.

De La Tour held strong views on portrait painting; it was not enough merely to capture a flattering likeness of his sitters. "Unknown to them," he said, "I descend into the depths of my sitters and bring back the whole man." This painting, like all great portraits, tells us much more about the sitter than the mere details of his features and attire. De La Tour painted many self-portraits, as a means of discovering how to give his work the quality of animation that he sought, experimenting with facial expressions, and repeatedly analysing the structure of his face.

Although the pastel medium had already become popular, de La Tour was the first artist to make it seem a genuine rival to oil paint. He liked the medium for its immediacy and speed of application, although he often grumbled about his "colored dust" and the difficulty he had with blending colors and achieving the correct tone. He was also concerned about the fragility of his pastel works, experimenting with various methods of fixing the pigment to prevent deterioration. But he need not have worried—this portrait, together with many others, has survived for 250 years, to look as fresh and vital as the day it was painted.

ABOUT THE ARTIST

Little is known about the early years of Maurice-Quentin de La Tour (1704–88), except that he defied his father, who wanted him to be an engineer, and left home to study in Paris when still in his teens. He trained originally as an oil painter, but was converted to the pastel medium by the hugely successful Venetian pastel painter Rosalba Carriera, who visited Paris in 1721–22. He made his name as an artist in 1737, when he sent in to the Salon a self-portrait and a painting of a young woman, both of which impressed the judges with their realism and technical skill. Thereafter, he painted all the notables of his day, including the philosophers Voltaire and Rousseau, and the king's mistress Madame de Pompadour—the latter a full-length portrait, and the largest-scale pastel painting ever to have been made. He became portrait painter to the king, Louis XV, in 1750, and remained in this post until he had a mental breakdown in 1773. He had always been temperamental, arrogant, and sometimes ill-tempered with his sitters, as well as prone to obsessive doubts about the value of his own work.

EQUIVALENT COLORS

If you were to try to recreate the colors of the original painting in pastel, the following colors would be useful as a basic palette:

Background:

Face and hair:

Fur collar and neck tie:

Velvet coat:

POINTS TO WATCH

Anyone who is interested in portraiture naturally wants to express something of the character of their sitter, rather than just capturing a superficial likeness. Many professional artists like to get to know their subjects as people before painting them, often staying in their homes over a period of time, so that they can observe characteristic postures and facial expressions. These have an important bearing on creating an in-depth portrait, so try to take time for preliminary observation. When you are setting up the pose, give careful thought to lighting, because if the light is too flat you will not be able to make the head look solid. And finally, never forget the importance of composition. In a head-and-shoulders portrait like this, you must decide on your angle of viewing, at what point to "crop off" the body, and how to place the head.

Placing the head
The head is placed slightly off-center, so that there is more space on the right side than the left, and there is sufficient space above the head to prevent it from looking cramped.

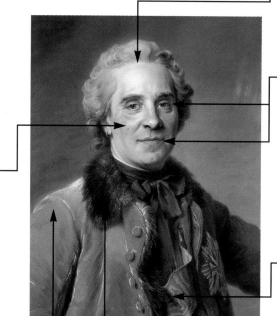

Facial expression
The lips are relaxed, as though the sitter has just been smiling at some private thought, an impression that is heightened by the inward-looking gaze of the eyes. A direct eye-contact with the viewer always has a slightly confrontational aspect.

Lighting
The light comes from the left and slightly to the front, a form of lighting that is known as three-quarter, because it illuminates three-quarters of the face, casting the far side into light shadow.

Cropping
The lovely swirl of blue just touches the frame at the bottom, making an ideal cut-off point. Where you decide to crop in a head-and-shoulders portrait depends very much on what the sitter is wearing.

Angle of viewing
The artist is viewing the sitter at a slight angle, so that the line of the shoulders is slanted, giving a diagonal that is balanced by that of the arm going out of the picture on the right.

Tonal balance
The fur collar and cravat make a dark shape that counterpoints the pale oval of the face and sets off the mid-toned red-brown of the coat.

FOCUS ON TECHNIQUE

Pastel is often seen as a medium that is best for broad effects and impressionistic approaches, but, as this portrait shows, it can be very carefully controlled and can create remarkably precise effects and fine detail. Thorough blending (see p. 76) in the early stages of the work is the key to producing this kind of effect. De La Tour probably used a variety of rolled-paper stumps (torchons), still available in art shops, but these are best restricted to small areas. For large areas you can push the color into the surface and rub colors together, using the heel or palm of your hand. You will need a paper that holds the pigment well, such as very fine sandpaper, and you may find it helpful to spray the work with fixative at various stages. De La Tour probably painted on a specially formulated rag paper; he insisted on high-quality materials, and it is known that he corresponded at length with paper manufacturers.

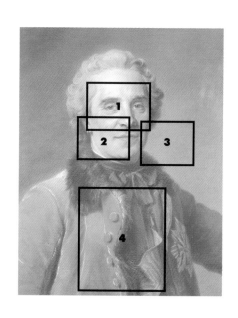

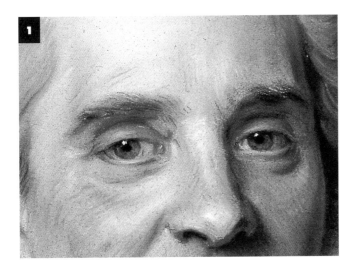

Eyes and hair (above)

The eyes are rendered with consummate skill, first building up the shape of the eye socket, and then defining the lids with a sharp piece of pastel, and adding the all-important highlights. For the blue-gray of the pupils, colors would have been blended with a small torchon. The eyebrows and hair are drawn with individual strokes over a base gray color, with thicker, curving strokes used for the hair.

Strokes over blends (above)

For the face, colors would have been blended until the correct color and tone values were achieved, and then overlaid with more linear marks, made with the point of a pastel stick. These follow the direction of the forms, helping to build the solidity of the head.

Blending large areas (above)

At least four colors have been laid down together and blended into one another. They are close together in tone, so that the background reads as an almost continuous area of color, just a little lighter on the left, where the paler blue contrasts with the shadowed side of the face.

Describing texture (right)

The texture of the fur collar is imitated with fine, linear marks following different directions, in both light and dark tones worked over a mid-toned blend. For the velvet coat, broader, smoother strokes are used, except where the folds catch the light. For the blue watered-silk sash, squiggling marks of pale blue are worked over a darker base color.

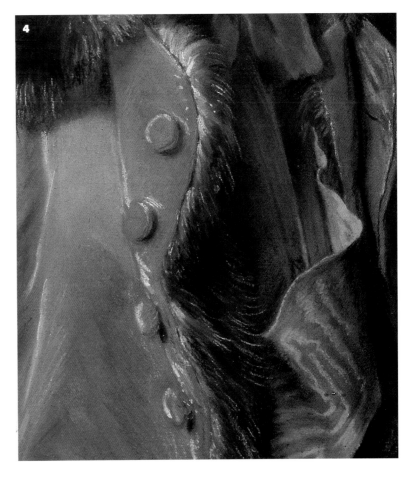

TUTORIAL: Painting Portraits

In her painting "Jeremy," Sharon Finmark has produced a portrait of considerable power. The painting relies more on tonal contrasts than on color for its impact, with the somber browns and grays expressing a mood of quiet reflection that is backed up by the direction of the sitter's gaze. Instead of engaging in direct eye contact with the viewer, and thus imparting a confrontational aspect to a portrait, he looks off to one side, seemingly deep in thought, his mouth unsmiling but relaxed. Without treating the face with an unnecessary degree of detail, the artist has nevertheless paid careful attention to the features, noting the shapes of the eyes, mouth, and nose, as well as the overall shape of the head.

Jeremy,
by Sharon Finmark

COLORS USED

Because the names of pastel colors vary widely according to the manufacturer, we show the colors only as swatches. If you do not have these colors, most art-supply stores will offer a corresponding range.

Background:

Face:

Jacket, shirt and hair:

TECHNIQUES USED

Blending	page 76
Charcoal and pastel	page 78
Details and edges	page 81
Side strokes	page 88
Surface mixing	page 89
Underdrawing	page 91

1 Underdrawing (right)

The artist is working on a mid-toned, gray, Mi-Teintes paper, using the rough side, that holds the pastel pigment well and facilitates blending methods. She begins with a careful drawing, using both white and brown pastel pencils.

2 Laying the base color (left)

Everyone has their own, distinct skin color, and it is important to identify this before engaging with local variations and effects of light and shadow. In this case, the base color is a warm pinkish yellow, and these colors are laid on first, with an accent of light red on the cheekbone. Hard pastels are used for this blocking-in stage.

3 The background color (below)

The sitter's face and clothing will dictate the colors used, but for the background the artist has a relatively free choice. She decides on a deep, cool blue-gray that will contrast with the warm colors of the skin and jacket. She uses soft pastel to work a deep indigo over a slightly lighter color, pushed well into the grain of the paper.

4 Hard and soft pastels (left)

Next, she lightly blocks in the brown of the jacket and the white cravat, which is the lightest tone in the composition. Here again, she uses hard pastels—these adhere to the paper better than soft ones, and thus provide a solid foundation on which to build further colors at later stages.

6 Using charcoal (above)

The eyebrows are drawn in with charcoal, a medium often used in combination with soft pastels. For areas like this, it is better than black pastel or pastel pencil, because it creates a much softer effect and also gives a hint of texture.

5 Pastel pencils (right)

With the paper now fully covered and the basic tones and colors established, she turns back to the face, picking out small linear details with pastel pencils. These are easier to control than soft pastels, and being harder are thus less prone to accidental smudging.

7 Cool shadows (left)

A gray-blue pastel pencil is used to accentuate the shadow down the side of the face, giving a stronger form to the head. The colors in shadow areas are always cooler than those in the highlights, and there is also some reflected color from the background.

8 Anchoring the figure (right)

The chair is indicated with turquoise blue, that will later be modified with other colors. The curve of the chair is important for two reasons. First, it provides a compositional balance for the elongated curve of the jacket lapel on the right, and second, it anchors the figure and explains his posture. Since the hands and upper legs are not included, it is mainly the chair that tells us that the figure is seated rather than standing.

9 Soft over hard (right)

With the main color of the jacket blocked in hard pastels, the artist now begins to layer other colors over it with soft pastels, gradually building up the shadows and highlights formed by the creases in the fabric. It is vital to place these carefully, because they explain the forms beneath.

10 Blending with pastels (below)

Blending can be done with the pastels themselves, as well as with the fingers or a blending implement. There is now a considerable build-up of pigment on the face, so the color now applied with pastel pencil blends into the earlier ones, rather than sitting on top of them.

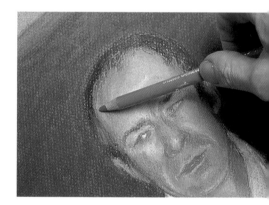

11 Direction of light (left)

The background is to be lighter on one side, partly to create additional interest and help the shoulder to stand out, and partly to explain the direction of the light. White is laid over the dark color with squiggling strokes of white pastel and rubbed in with a finger.

12 Final emphasis (right)

The white cravat is very important to the composition, because the pale shape leads the eye up to the face. This diagonal formed by the folds of the fabric requires extra emphasis, so the shadow is strengthened with a gray-green pastel pencil. Again, a blended effect is created, where the darker color sinks into the earlier, light ones.

The finished picture has a composition which is simple, but strong and well balanced, and the colors are somber but far from dull. Although use has been made of blending methods, the pastel marks are still visible in certain areas, providing surface contrasts that give the picture extra interest.

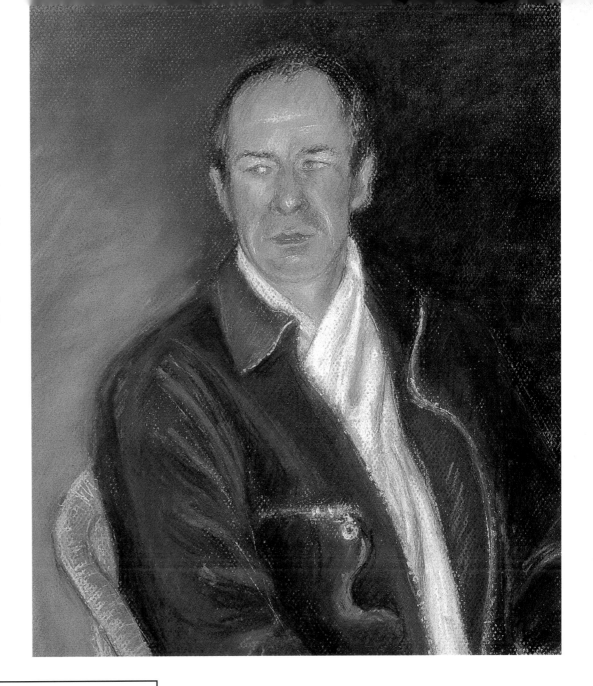

Placing the head
The placing of the head is vital in portraiture. Here, there is enough space above it to prevent it from looking cramped, but not so much that it seems to be pushed downward.

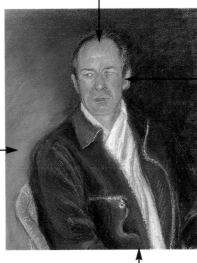

Lighting
The light comes from the right, providing sufficient tonal contrast to model the forms of face and body, and throwing the left shoulder into shadow so that it merges with the background.

Thoughtful blending
Care has been taken not to overblend, even in this background area. The artist used her fingers in the direction of the pastel marks so that you can still just see the pattern of light over dark.

Cropping
Deciding where to crop the figure, and whether to include the hands, is equally important. By cutting off the body above the hands, the artist has been able to exploit the pale shape made by the cravat and the long curve of the lapel, that lead the eye upward to focus on the face.

41

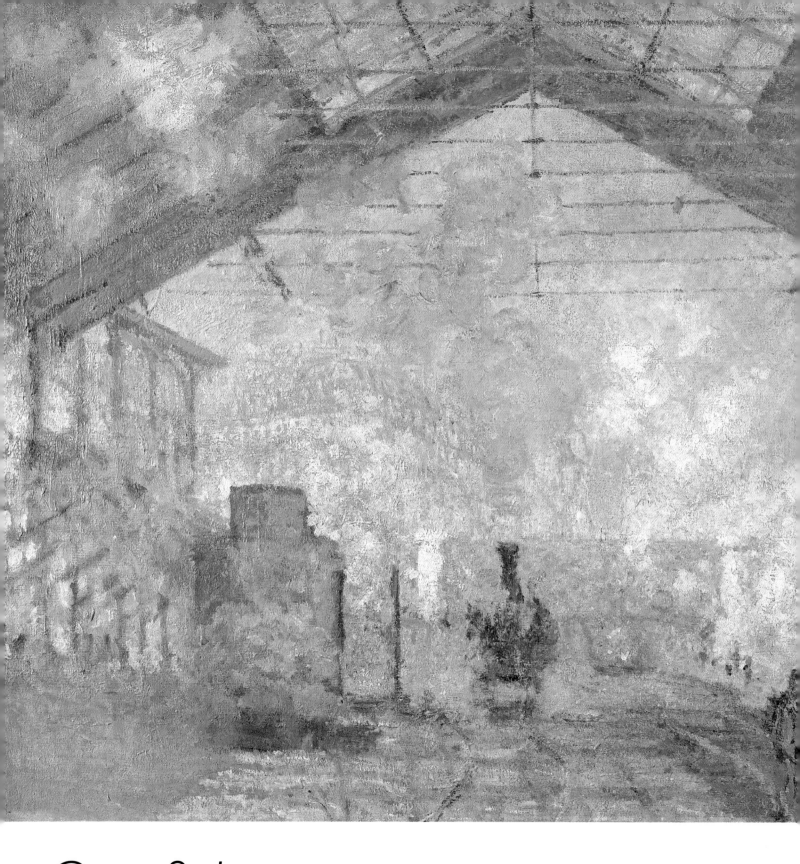

Gare St Lazare, Claude Monet, 1877

This painting dates from Monet's years in Paris, before he moved out of the city and turned to pure landscape. He was fascinated by the subject, and made 12 paintings of it in a short space of time. Some of these were quick sketches that were later finished in the studio, but this was painted on the spot. He requested permission to set up his easel directly beneath the canopy, in order to make the most of the delicate glass and iron structure, and the way it acted as a frame for the engine and the sunlit buildings beyond—the

Gare St Lazare,
by Claude Monet (1877)
Oil on canvas,
Musée d'Orsay, Paris.

composition arises directly from this chosen viewpoint. The engine, the focal point of the picture, is placed directly in the center, but the symmetry is broken by the pattern of the smoke, leading up to the top left, by the large shape of the carriage, and by the slightly off-center placing of the peak of the canopy. Although Monet has introduced figures, they are mainly a compositional device, providing verticals that echo those of the background buildings. As in Monet's later landscapes, the main theme of the painting is light, and he has expressed this through very careful control of tone and the repeated use of the complementary contrast of blue and yellow.

ABOUT THE ARTIST

Claude Monet was born in 1840 and died in 1926, thus spaning eight decades in a rapidly changing world. From our point in time, which gives us an overview of the early 20th century, it seems incredible that toward the end of Monet's life, when he was composing his masterly paintings of water lilies in his garden at Giverny, Cubism was already a well-established movement and Marcel Duchamp was expounding the anti-art theories of Dadaism. But despite the welter of new ideas current at the time, Monet remained faithful to the ideals of the movement he himself had given birth to. When still a young man, he had been introduced to the idea of outdoor painting by an older artist, Eugène Boudin, and the truthful depiction of nature and the effects of light remained his abiding passion.

By the end of the 19th century Monet had become one of the "grand old men" of the Impressionist movement, with many patrons and admirers, and sufficient funds to employ six gardeners to maintain his self-designed water garden at Giverny. But recognition had come slowly; during his early life, he and his family were often in serious financial straits. It is an irony that the very term "impressionism" was originally intended as a condemnation. A hostile critic used it in a review of the First Impressionist Exhibition, pouring scorn on the "half-finished" look of many of the paintings on show. The label stuck, to become in our own time an accolade.

EQUIVALENT COLORS

If you were to try to recreate the colors of the original painting in pastel, the following colors would be useful as a basic palette:

Outside background:

Roof and foreground:

POINTS TO WATCH

In an urban landscape, especially when your main concern is light, you will need to be prepared to edit reality to some extent. There may be objects, such as ugly garbage cans and other street furniture, that don't help the composition, and often there is simply too much detail, which can cause you to lose sight of the main objective. Remember that you are interpreting the scene, not copying it, so work out your composition before you begin to paint, and decide what is most important. If you are including figures, take care with their placing and treatment. People are a natural feature of urban scenes, and by excluding them you could sacrifice atmosphere. But if you place them too near the front of the picture, or treat them in too detailed a manner, they will become the focal point, because our eye is always drawn to our fellow humans. Although Monet has placed figures in the foreground, he has painted them in such general terms that they might almost be a landscape feature. They are mainly a compositional device, providing verticals that echo those of the background buildings.

FOCUS ON COLOR AND TONE

In landscape painting, the quality of the light has as much importance as the objects that make up the composition, whether trees, hills and fields, or buildings, and to convey this successfully you must pay careful attention to both tone and color. Here, the sunlight is gentle, diffused through a light haze of mist and smoke, and there are no very dark tones or sharp transitions from dark to light. The color scheme is based on the blue-yellow complementary contrast, creating a wonderfully vibrant but delicate effect that you can see recurring in many paintings by Monet and the other Impressionists. These artists were not the first to exploit juxtapositions of complementary colors, but they were unique in making systematic use of them. The scientific theories about color that had begun to be formulated from the second decade of the century were much discussed in artistic circles, and these pioneer painters were especially eager to absorb and utilize new ideas.

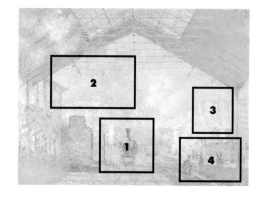

Perspective and proportion
However broadly you intend to treat buildings, they must appear logical in terms of structure, so it is wise to begin with a drawing that establishes the main proportions as well as the angles of perspective.

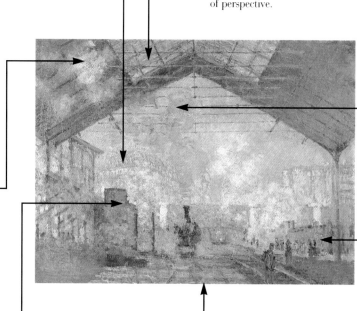

Pictorial links
The eye is led from one part of the painting to another because the artist has set up a series of visual links, or echoes. The white area of the smoke links with the puffs below and on the right of the engine.

Viewpoint
The choice of viewpoint is vital, because it provides the bones of the composition. In this symmetrical composition, Monet has used the canopy as a frame for the engine and the view beyond, but he has broken the symmetry, first with the large shape of the coach, and second with the swirl of smoke.

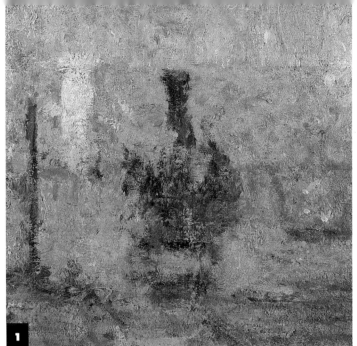

"Knocking back" dark tones (left)

The engine is the darkest area of tone in the painting, and here there are touches of pure black together with very deep, rich blues. But instead of painting the shape with heavy slabs of color, Monet has built it up with a series of small brushstrokes, with light tones among the dark, so that in the context of the painting it reads as a middle tone.

Broken color (left)

Another artistic device used to convey light effects is to avoid flat areas of color, instead building up each area with small brushmarks of related colors. Pastel is ideally suited to these broken-color effects that can be made either with point strokes, or with short side strokes laid into and over one another.

Complementary colors (above)

The blue-yellow color theme is taken through the whole painting, but this area shows it most strongly. The shadows on the buildings pick up the same blue used for the swirl of smoke, making a vibrant contrast with the sunlit yellows.

Rhythm and movement

The smoke plays a dual role, not only providing the all-important blue to contrast with the warm yellows, but also giving life and movement to a composition that might otherwise have been static.

Painting figures

Figures also must appear believable, however sketchily they are treated, so try to observe overall shapes and postures, and the way people move. If you get these right, you will be able to suggest a figure with just a mark or two with your pastels.

Leading the eye

The curving lines of the rail track, added at a late stage in the painting, draw the eye in from the front of the picture plane to the engine in the middle distance, establishing its place in space.

"Colored" neutrals (above)

In this area of quiet color, as on the underside of the canopy (see 2), the two main complementary colors have been brought into mixtures. Remember that you can make lively browns and grays by mixing any pair of the complementaries, and this will also help to give consistency to the composition.

TUTORIAL: Urban Landscape

For anyone interested in urban landscapes, railroad stations are an excellent subject. They allow you to paint or sketch without attracting too much attention, because the people who throng the platforms or concourses are focused on their own concerns. Many stations are also of architectural interest. Monet was fascinated by the delicate ironwork of St Lazare Station, while Debra Manifold has found equal inspiration in the cathedral-like concourse of New York's Grand Central Station. In her painting "Grand Central Station," she has, like Monet, explored the effects of light, in this case both natural and artificial, providing her with an extra challenge. She is working on mid-toned gray Fabriano Tissiano paper.

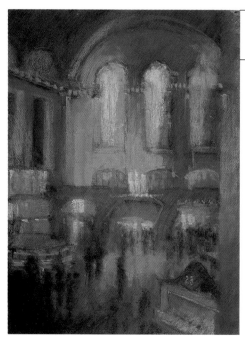

Grand Central Station, *by Debra Manifold*

COLORS USED

Because the names of pastel colors vary widely according to the manufacturer, we show the colors only as swatches. If you do not have these colors, most art-supply stores will offer a corresponding range.

Windows and light sources:

Interior, floor and people:

TECHNIQUES USED

Blending	page 76
Overlaying colors	page 85
Side strokes	page 88
Surface mixing	page 89
Underdrawing	page 91

1 Tonal underdrawing (above)
The artist often paints on location, direct from the subject, but in this case is working from visual reference, in the form of a photograph. She has begun with an underdrawing in dark olive-green, establishing both the main lines and the tonal structure of the composition.

2 Blocking in (right)

The artist's method is to cover the whole paper as rapidly as possible, blocking in the first colors with light side strokes and gradually building up to heavier applications. She starts with the dark green and red-brown on which the color scheme is based.

3 Blending (below)

The blocking-in process continues, with the middle tones being built up gradually. The gradations of tone in this area are to be soft, so a hog-hair brush is used to blend the colors together.

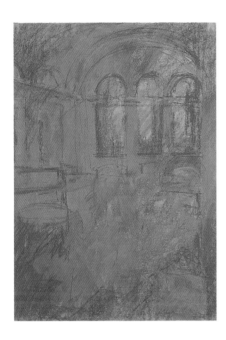

4 The key color (left)

The paper is now largely covered, though with a little of the gray paper still showing through the light sidestrokes. This glowing red-brown is the key color in the painting, and with this established, the artist can now consider the other colors.

5 Overlaying colors (above)

The artist begins to build up the colors more thickly, laying yellow ocher over the red-brown more heavily than before. The paper has a pronounced grain that holds the pastel color in place well.

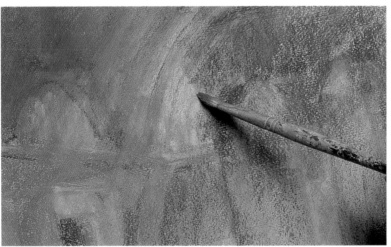

6 Light effects (above)

The string of small red lights, and the way they reflect on the walls and window arches, was one of the most attractive features of the subject, but the accents of brilliant red will be added later. At this stage, the artist concentrates on the broader area of reflected light, laying orange over the darker red-brown, and blending to soften the transitions of tone and color.

7 Relating colors (right)

Throughout the working process, the artist assesses one color and tone against another, heightening or muting colors as required. She can now see the windows in relation to the warm colors of the arches, and lays a warm mid-toned blue over the earlier colors. This contrasts well with the rich browns and ochers.

8 Relating tones (right)
The tones in this area need to be judged very carefully. The window wall is darker than the sky at the top, but lighter below, where light is reflected from the strip lights beneath. The pastel is used quite heavily to lay light ocher over the previous darker color.

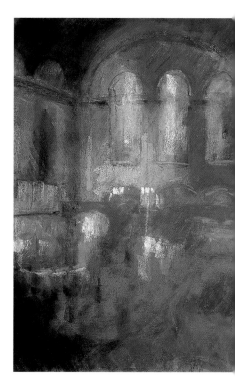

9 Working up and down (right)
The painting strategy is based on starting with the middle tones and working gradually up to the lights and down to the darks. The artist has now brought in darks at the top and bottom, and has begun to indicate the bright areas of reflected light.

11 Color adjustments (left)
Again judging one area of color against another, the artist sees that the window arch needs lifting slightly. She drags the side of a blue-gray pastel stick over the earlier colors, applying very light pressure so that it catches only on the top grain of the paper to create a shimmering, broken-color effect.

10 Color accents (above)
The artist can now concentrate on the most enjoyable stage of the painting—adding the vivid color accents, defining a few chosen details, and making subtle adjustments to the colors. She uses a short length of bright red pastel to make small, square marks for the lights running around the tops of the walls.

12 Building up color (below)
A similar method is used to build up the area in the center of the painting, preparatory to adding the people and other details. The effect of these successive veils of color is more vibrant and exciting than flat color.

13 Suggestion (above)
The people are treated as no more than suggestions, with no color used for individual garments, and no precise delineation; their role is mainly to reinforce the vertical emphasis of the composition. They are laid in with black pastel, which was then worked around with light brown.

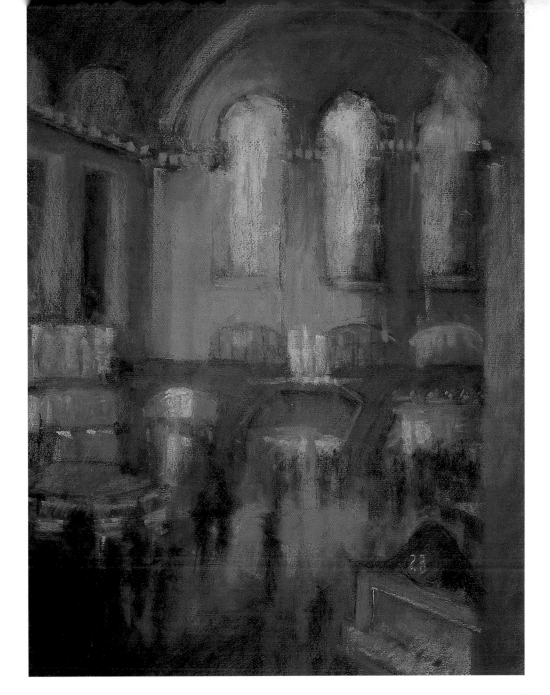

The finished picture has a lovely, rich glow, deriving from the skillful manipulation of colors in a limited tonal range. The composition, based on the interaction of verticals and curves, is beautifully balanced.

Direction of strokes

The direction of the pastel marks plays an important part in stressing the vertical emphasis of the composition. The decisive, upright strokes used for the central area of light were strengthened in the final stages, to form a more definite focal point and to lead the eye up to the tall windows and arch above.

Color relationships
Throughout the painting, the artist has exploited the way colors are affected by those that surround them. This yellow ocher, which in another setting would appear warm, takes on a cool, slightly greenish hue in relation to the rich red-browns around it and the accents of pure red beneath.

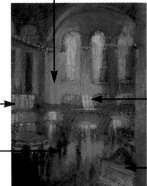

Color accents

These touches of brilliant blue, echoed elsewhere in the painting, contrast with the main ochers and red-browns to make the whole color scheme sing.

Suggestive detail
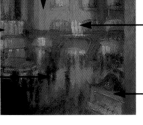
In spite of being treated so broadly, the tall shapes are recognizable as figures mainly because the artist has observed the overall shapes and groupings, with some figures close together and others more widely separated in space.

Compositional decisions
When she began the painting, the artist had not intended to include this foreground object. In the final stages, however, she decided that it made a balance for the circular stand on the left, as well as providing a curve to echo those in the middle distance.

The Tub, Edgar Degas, 1886

We are now so familiar with Degas' paintings of naked or half-clothed women washing, dressing, or brushing their hair that it is difficult to appreciate the extent to which they broke new ground. But no one had treated the female body in quite this way before: the nude had been idealized, presented as a thing of beauty posed for an audience, while Degas' nudes are depictions of real life. As he said, ". . . It is as though you looked through a keyhole . . . She is the human animal attending to itself, a cat licking herself." Degas, like other artists of his day, was much influenced by photography, liking the way the camera caught people unaware, unposed, and natural, and he tried to convey this impression in his work. But although he sought the effect of spontaneity, paintings such as this are not rapid studies done from life; all his works were planned with meticulous care. This

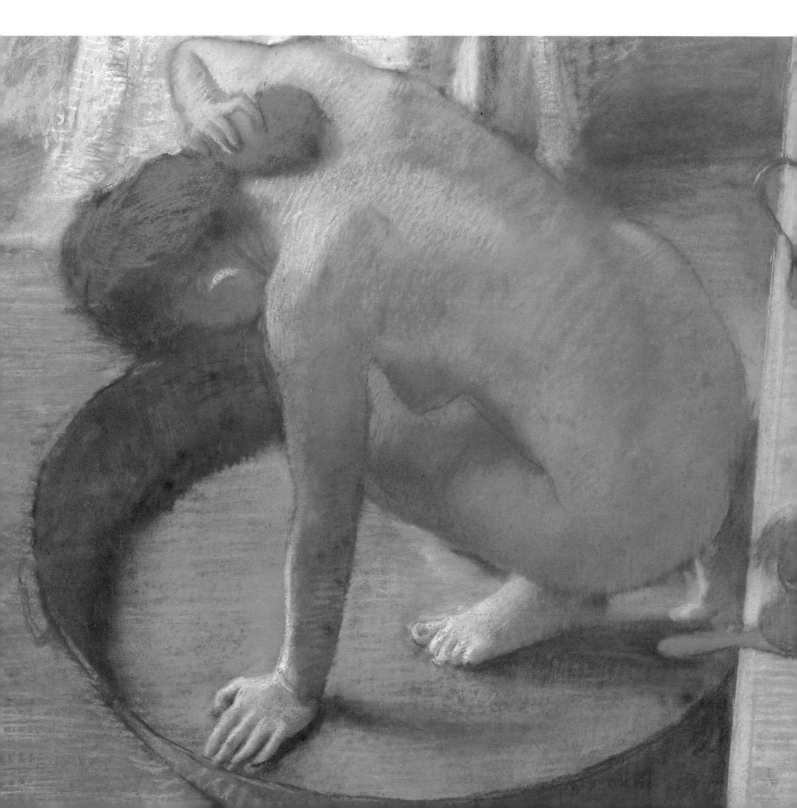

composition, for which he has chosen a high viewpoint, is particularly bold, with the hard, almost vertical, line running from top to bottom contrasted with the circle of the tub and the soft roundness of the woman's body. The way in which he has cropped objects, with the table, the bottom of the tub, and the background drapery going out of the picture, represents a complete break with the "classical" type of composition, in which all the elements are contained within the frame.

The Tub,
by Edgar Degas (1886),
pastel,
Musée d'Orsay, Paris.

ABOUT THE ARTIST

Edgar Degas (1834–1917) was the son of a rich banker, and had none of the financial problems that plagued many of his friends and contemporaries. He studied at the École des Beaux Arts in Paris, having abandoned a career in law, but gained his true artistic education through private study of the work of the old masters in Italy.

Degas is often loosely described as an Impressionist, and he did exhibit with the group on several occasions, but in fact his concerns were quite different, and he remained to some extent aloof from the movement. While artists such as Pissarro and Monet aimed to capture fleeting effects of light in landscape, working directly from the subject, Degas had no interest in landscape painting. His chosen subject was figures, including scenes at the races and the well-known paintings of dancers, and although he drew constantly from life, his paintings were constructed from sketches and acquired knowledge, rather than being composed on the spot.

He had always worked in pastel as well as oil, and when his eyesight deteriorated in the 1880s, he turned to the medium more seriously,

finding it ideal not only because it combined painting and drawing, but also because it allowed him to work broadly, without too much reliance on detail.

EQUIVALENT COLORS

If you were to try to recreate the colors of the original painting in pastel, the following colors would be useful as a basic palette:

Background:

Body:

Hair, jugs and combs:

Bath:

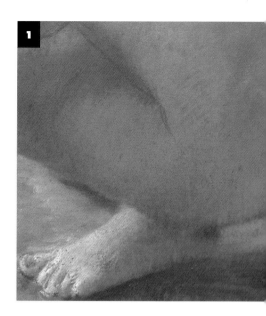

COMPOSITION: POINTS TO WATCH

If you are simply drawing the nude in a life class in order to gain experience, composition may not be high on your list of priorities, but for a painting of a figure in a setting, it becomes all-important. The figure will be the main subject of the painting, but you must relate it to the other elements as well, by the way you use colors and organize the interplay of shapes. If you attend a life class and have amassed a series of drawings, you may find it an exciting and instructive enterprise to use one of these as a starting point for a painting, placing the nude in the context of a room, perhaps your own bedroom or bathroom. Give plenty of thought to the viewpoint that you choose, as this affects not only the composition but also the mood of the painting. Degas has chosen a high, close-up viewpoint, which puts the viewer in the "fly-on-the-wall" position of close observation without direct engagement.

Viewpoint and perspective
Because of the effects of perspective, a circle becomes an oval (ellipse) the nearer it is to your own eye level. But if you look at it from above, it retains its shape identity, which in this case is very important to the composition, with the near-circle providing a balance for the rounded curves of the body, and a contrast to the hard line of the table.

Hard and soft
The edge of the table makes a clean, crisp line that gives dynamism to the composition, as well as drawing attention to the contrasting softness of the body. The near-vertical of the table is repeated in the folds of the drapery above the woman's back.

Cropping
Cropping objects has the effect of bringing the viewer into the composition, giving the sense that they are not constrained within the frame, but continue outside it. Here it also gives prominence to the curve, which runs counter to the curve of the woman's body.

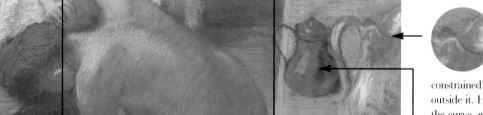

Repeating colors
The color of the jug, and of the wig below, pick up the color of the woman's hair, making further links between the two areas of the composition. A muted version of this same color also appears on the woman's arm and leg.

Balance and contrast
The crescent shape formed by the edge of the tub balances the curve of the buttocks and leg, and contrasts with the vertical of the arm. There is also textural contrast, with the hard, metal surface acting as a foil for the body's softness.

Making links
The handle of the hairbrush, jutting over the table edge, makes a link with this area and the tub. At the same time it adds a recessional dimension, pushing the tub and figure slightly back in space.

Varying the methods (left)

To describe the soft roundness of the buttock and thigh, the first colors have been rubbed into one another, or possibly wetted and worked with a brush. Very delicate marks have been applied over this base color with the point of the pastel sticks. The harder, bonier structure of the foot is defined more positively, with a heavy application of very pale pink over a mid-toned yellowish gray.

Descriptive mark-making (below)

The angular planes of the shoulders are worked with decisive, diagonal hatching strokes emphasizing this light-struck area. Where the top of the arm and the rib-cage turn away from the light, thicker strokes of pale, cool blues and greens have been lightly dragged over a base tone. The hair is worked light over dark, with yellow-brown directional marks, while the face is again softly blended so that the edge is "lost." The position of the head is explained by the "found" edge of the ear, worked over the darker color with one deft stroke.

FOCUS ON TECHNIQUE

Degas pushed his chosen medium to its limits. He would sometimes mix pastel with other media, such as oils or monotype prints, and he often worked on board rather than paper, building up rich depth of color by mixing the pastel into a kind of paste with a fluid medium of his own invention. What distinguishes his pastel works from those of earlier practitioners is his avoidance of blending techniques. There are small areas of blended color in this painting, but in most areas the pastel marks are exploited as an integral part of the painting. The forms have been described less by conventional tonal modeling than by the direction of the pastel marks, and the use of warm and cool colors.

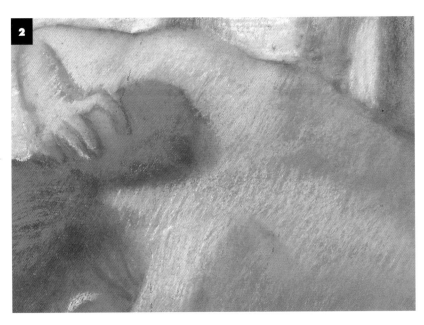

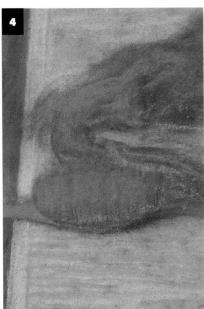

Warm and cool colors (above)

Here, the contrast of warm and cool colors is used to model form, as well as to give extra punch to the overall color scheme. The side of the arm catches the light coming from above left, creating a warm, pinkish brown, juxtaposed with a band of cool blue running down the arm. On the right side, touches of warm brown caused by reflected light are enclosed by a thin band of cool blue-gray. The dark crescent of cool color formed by the tub's side is the perfect foil for the warm colors—the red-brown hair, the floor, and the objects on the table.

Directional strokes (right)

The marks of the pastel sticks in this area are very varied. The flat plane of the table top is treated with horizontal strokes, except at the extreme edge, where a single vertical stroke runs from bottom to top. The wig is described with short, blunt, curving strokes, interspersed with one or two sharper diagonals, while the fuzz of the hairbrush consists of rubbed-in color with a few very delicate, dark lines at the nearer edge. Long, sweeping curves create the form of the jug.

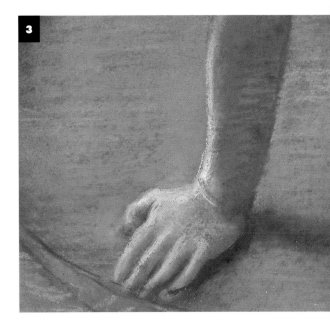

TUTORIAL: The Nude in Context

Sharon Finmark's painting "Getting Dressed" clearly shows the influence of Degas, whose pastel methods and treatment of the nude have proved a source of inspiration for many of today's artists. But she has evolved her own distinctive style and approach, and the painting is a highly personal response to the subject. She works on the textured side of gray, Mi-Teintes paper, and uses both hard and soft pastels, plus pastel pencils for the underdrawing and touches of detail.

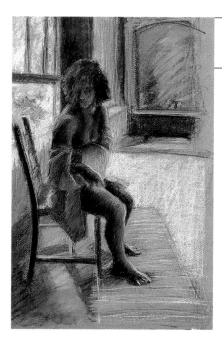

Getting Dressed,
by Sharon Finmark

COLORS USED

Because the names of pastel colors vary widely according to the manufacturer, we show the colors only as swatches. If you do not have these colors, most art-supply stores will offer a corresponding range.

Body:

Background:

TECHNIQUES USED

Blending	page 76
Colored grounds	page 79
Details and edges	page 81
Hatching and cross hatching	page 83
Underdrawing	page 91

1 Underdrawing (right)
The figure of the woman is dark in tone because she is seen against the light, so the artist begins with a firm underdrawing in black pastel pencil. For the head, she has restricted herself to outlining the main shape made by the hair, because she does not want dark lines on the face.

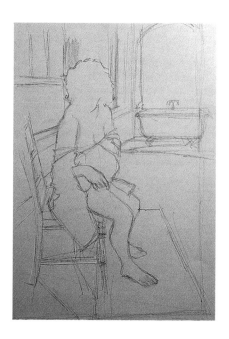

2 Laying base colors (right)
The red-browns of the body and hair are the key colors, that will later be contrasted with cooler colors and lighter tones, so she begins with these, using two tones of the same color, and overlaying broad sidestrokes with hatching strokes made with the point of the stick. She is using only soft pastel at this stage.

3 Filling the grain (right)

The rough side of this type of paper has a pronounced grain, that will add a touch of texture to certain areas of the finished work, such as the background. But the color on the body is to be built up solidly, so she rubs it well into the grain with her finger.

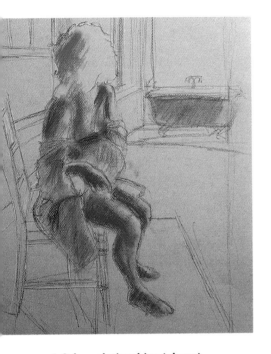

4 Color relationships (above)

There is now sufficient color on the body for the artist to start to introduce new colors in relation to it. She has brought in a mauve-gray for the clothing, repeating this on the bath at the back of the picture to form a link between the two areas. Throughout the painting process, she checks the relationship of colors over the whole of the composition.

5 Shapes and edges (left)

The shape of the leg is already established through the area of deep red-brown, but it is important to define fully this crisp edge, formed by the band of highlight where the leg and foot catch the light, so it is drawn in firmly with a sharp edge of cream-colored soft pastel.

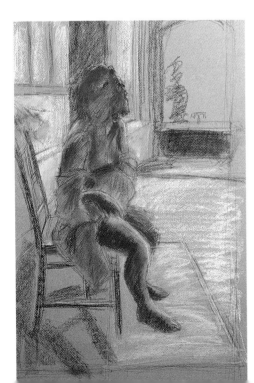

6 Color scheme and contrasts (left)

A further reason for putting in the highlight on the leg at an early stage was that it helped the artist to relate the colors of the figure to those of the room setting. To form a pictorial link, she has repeated the same color on the floor and wall behind the figure, and has begun to introduce the cool colors that contrast with the rich red-browns.

7 Working across the picture (above)

To preserve the unity and consistency of the composition, the artist works all over the painting at the same time, constantly checking one color and tone against another. With the cool, mid-toned gray of the window frame behind the head in place, she now works further on the body, bringing in a lighter red to suggest the slight prominence around the collarbone.

8 Blending methods (right)
To knock back the color of the floor slightly so that it takes its proper place in space, a little of the blue-gray used for the foreground rug has been laid over the yellow, and the two colors are now blended lightly. The artist is using a blending stump, or torchon, rather than her fingers, and she blends in the direction of the pastel strokes so that they are softened while still retaining their character.

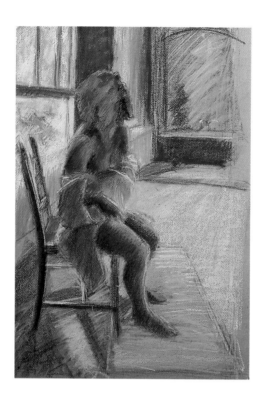

9 When to stop (right)
Deciding whether or not a painting is finished is one of the most difficult decisions an artist has to make. Inexperienced artists tend to overwork, in an effort to include every detail, thus weakening the effect. Here, the artist is aiming at a broad statement, but she decides that the figure, especially the head, should be brought into sharper focus and a little foreground interest should be added.

10 Sharpening up the image (above)
To separate the head and shoulder more decisively from the background, thus bringing the body forward, she uses a pastel pencil heavily to take light yellow around the darker colors. Pastel pencils are useful for such touches of definition, provided that the grain of the paper has not been fully filled; they are harder than soft pastels, and will not sit over a heavy application.

11 Spatial relationships (left)
Before adding final touches to the head, the stripes of the rug have been sketched in with a light yellow hard pastel, that contrasts with the blue-gray in both tone and color and thus brings the area forward in space. Notice that the yellow stripes have not been taken over the left side beneath the chair, because they would form a distraction by taking attention from the figure.

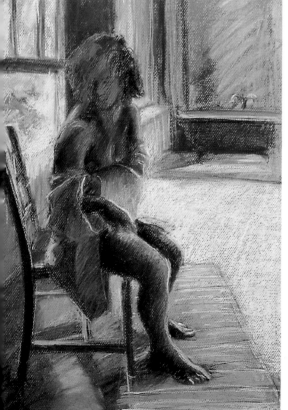

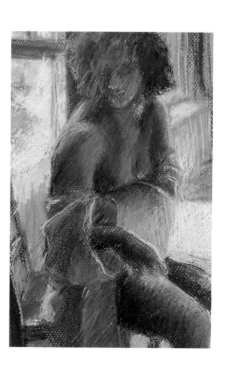

12 The last touches (right)
The final, but vitally important, touches were to add the tiny points of light that define the head and shoulders, and to bring in some darker tones around the chin and eyes to give the head and face a firmer structure.

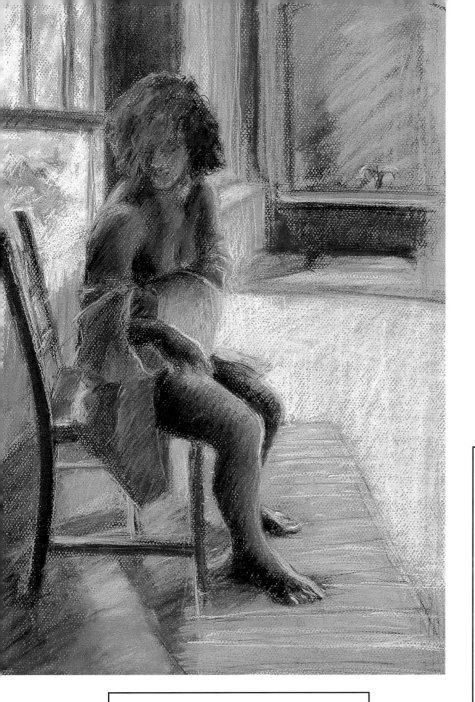

The finished picture uses mark making as an important element in the composition, with the firm, unblended pastel strokes giving a sense of life and vitality, and saving any one color area from becoming flat and dull. The color scheme, based on warm/cool contrast, is simple but effective, with colors repeated from one area to another to ensure total unity.

Pictorial devices
This light scribbling is one form of a device quite often used for windows or mirrors, where the artist wants to suggest the reflective surface without engaging with reflections or a view through the glass.

Viewpoint
The viewpoint chosen has an important bearing on the composition. It is not as dramatically high as in the Degas painting, but because the sitter is seated and the artist is standing, she can see more of the top of the head and the legs than if she were viewing at eye level.

Against the light
Much of the power of the painting stems from the way the figure has been arranged, with the light coming from behind. This effect, known as *contre-jour*, semi-silhouettes the figure, reducing the detail and producing deep, rich tones and colors.

Muted color
The green of the chair seat, repeated on the foliage outside and on various areas of the background, is the only departure from the basic color scheme of blue-gray and red-brown. So that it does not stand out too strongly, it was kept muted.

Leading the eye
The yellow stripes on the blue-gray not only help to define the space; they also catch the eye so that the viewer is led into the painting, thence traveling upwards along the feet and legs to the head.

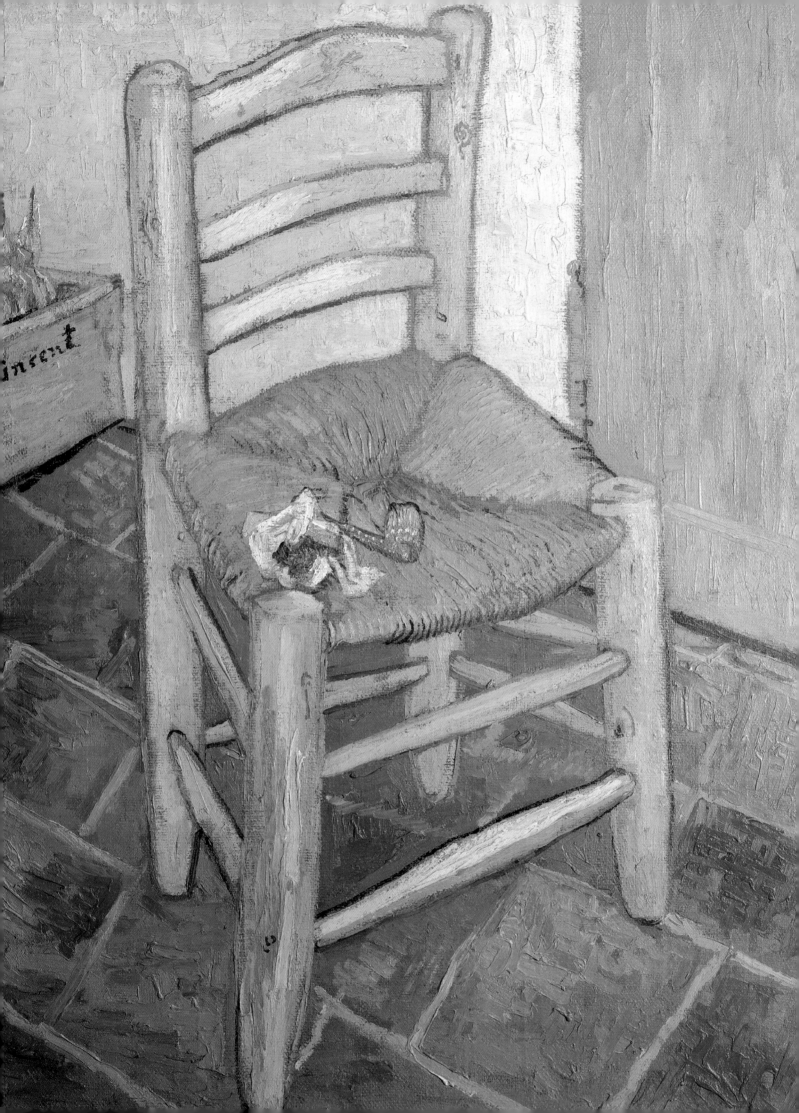

Vincent's Chair with his Pipe,
Vincent van Gogh, 1888

The label "still life" creates a mental picture of objects on a table top, and indeed, the majority of still lifes do feature fruit, flowers, bottles, and so on, arranged on a surface roughly corresponding to the artist's eye level. But any painting of inanimate objects can be described as still life, and this painting fits into the same category as Courbet's bowl of fruit on p. 68. There is an important difference, however, because this work has a personal dimension. Van Gogh is not just painting a chair; he is painting his own chair in the house in Arles where he lived for a time, stamping his personality on it by including the pipe he smoked when relaxing. The picture, together with another he painted of the bedroom of the house, tells a story about his life at the time. Van Gogh frequently painted personal possessions in this way—for example, one still life shows a pile of books (he was immensely well-read), and another a pair of battered boots.

Another departure from the more usual still-life set-up is the choice of a high viewpoint; he is looking down on the chair from above, so that the rush seat is seen in its entirety and the chair fills the whole of the central area of the picture. A high viewpoint tends to organize the subject into a more distinct pattern, and this pattern element has been heightened by deliberately distorting the perspective of the tiled floor.

ABOUT THE ARTIST

Vincent van Gogh (1853–90) has become an almost legendary figure —the epitome of the struggling artist who failed dismally during his lifetime, yet whose works now fetch record prices. Had he lived for a normal lifespan, however, he probably would have achieved some degree of fame and financial reward, because by the time of his tragically early death his unique and extraordinary talent was beginning to be recognized by other artists.

Van Gogh did not begin to paint until 1880, after several false starts in life. First he worked for his uncle, an art dealer, in London and Paris, and he then became an unpaid schoolteacher in England before deciding on a vocation as a lay preacher—his father was a Protestant pastor. It was during two years spent as a preacher in a grim, impoverished mining district of Belgium that his religious zeal channeled itself into his true vocation, and he decided to become an artist. He was supported by his loyal and generous brother, Theo, who made him an allowance from his own small salary, and for the ten years that remained of his life he painted with single-minded passion, even during his spells in the lunatic asylum. He had his first mental breakdown in 1888, just a month after completing the painting featured here, and shot himself less than two years later. It is a sad irony that he failed even in his last act, missing his heart, and dying in his bed in the village of Auvers, with his grief-stricken brother by his side.

EQUIVALENT COLORS

If you were to try to recreate the colors of the original painting in pastel, the following colors would be useful as a basic palette:

Floor:

Chair:

Background:

Box:

Pipe and rag:

POINTS TO WATCH

When painting a single object, such as this chair, plan the composition with as much care for the other elements as for the object itself. But remember that the object will be the focal point, so first decide how you will place it on the rectangle of your picture surface, whether to crop part of it or show it complete, and what viewpoint you will choose. If you want to paint the kind of semi-autobiographical still life that Van Gogh has, consider introducing some personal possession that you are fond of, or that helps to explain your interests. A sketchbook, a jar of paintbrushes, or a bag of knitting wools could be the equivalent of Van Gogh's pipe. Finally, when you

start to paint, try to give the subject extra interest by the way you handle the medium. In pastel you cannot emulate Van Gogh's luscious, thick paint, but you can add an extra dimension by using varied strokes and laying colors over one another.

Balancing shapes
The box on the extreme left balances the blue door; it is a smaller version of the same shape. The twin diagonals framed by the bottom of the box and door enclose the floor area that makes a frame for the chair.

Vertical balance
The blue door is a vital element in the painting's color scheme, but it is also important in compositional terms. The side follows the line of the chair leg, stressing the vertical emphasis of the picture, while the flat shape points up the more elaborate structure of the chair.

Surface interest
The network of multi-colored brushstrokes of thick paint gives additional interest to this area. In pastel you could achieve a similarly varied and exciting effect with short side strokes (see page 88) of reds, greens, pinks, and browns, though the color will not stand proud of the surface, as it does here.

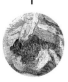

Angle of viewing
The angle at which the chair is seen is important, because it shows the whole of the structure clearly. In a more frontal view, the back legs would be hidden behind the front ones, weakening the effect, and making a less interesting series of shapes.

Cropping
By letting the leg of the chair go out of the frame at the bottom, the eye is led up it and into the picture. If the chair had also been cropped at the top, the eye would naturally follow the line straight out of the picture, but as it is, the top of the chair back makes a block.

The focal point
The little "mini-still life" on the chair is important in pictorial terms, as well as narrative ones. The small shapes on the larger one, and the neutral gray-white against the richer, darker yellow, draw the eye, providing a subsidiary focal point for the painting.

FOCUS ON COLOR

In one of his letters to his brother, Van Gogh described the painting of the bedroom that preceded this work: "This time it's just simply my bedroom, only here color is to do everything." In this painting also, color is the primary component, transforming a humble subject, that might have been dull in other hands, into a wonderfully rich and satisfying statement. Van Gogh had read widely on the subject of color, and was the first artist to deliberately exploit its expressive qualities. Here, the color

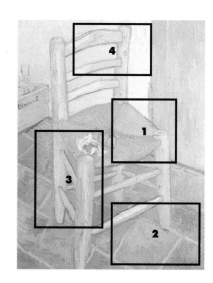

scheme is based on the blue/yellow complementary contrast, with more subtle touches of the other pair of complementaries, red and green.

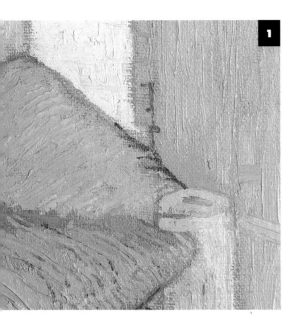

Color and tone (left)

Here, you can see the juxtaposition of one pair of complementary colors, blue and orange-yellow. These contrasts work best if the colors are kept close in tone, as they are here, with the blue mixed with white to equal the naturally lighter tone of the yellow. The color theme is repeated on the door, with a thin stripe of yellow painted over the blue wet in wet, so that the two colors have mixed slightly.

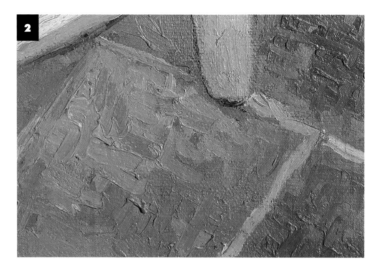

Red/green contrasts (above)

This passage of the painting brings in muted versions of the other pair of complementary colors, red and green, with mixtures made from these two colors. Notice how the richest area of red, behind the strut of the chair, is balanced by a slash of green, while the other tiles are painted with interweaving brushstrokes of greens, reds, and pinks.

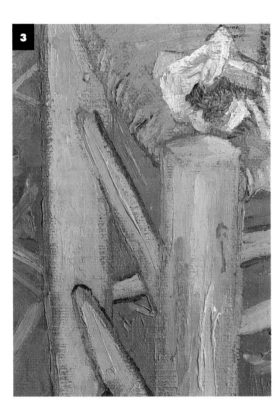

Structural emphasis (above)

The bold blue outlines around the legs and struts of the chair give strength and solidity to the structure, as well as continuing the complementary color theme and separating the blue/yellow areas from the red/green areas of the floor.

Color unity (above)

To relate the two main areas of complementary contrast, Van Gogh has brought in a little green on the back of the chair, and has also used small amounts of both green and blue in the light mixture for the background wall.

TUTORIAL: Painting Personal Objects

Pip Carpenter's still life, "The Tea Table," has a less obvious narrative content than the Van Gogh featured on the previous pages, but there is nevertheless a story behind it, which is personal to the artist. The tea service was the proud possession of a British friend living in Spain, and it was brought out at every opportunity. Partly to please her friend, and partly because she was struck by the Mediterranean colors, the artist made an on-the-spot sketch and constructed the painting later in her studio. She is working on a pink-beige, Mi-Teintes paper and uses both soft and hard pastels.

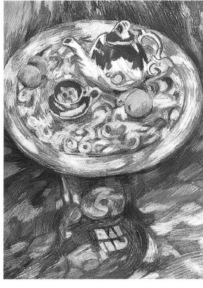

The Tea Table,
by Pip Carpenter

COLORS USED

Because the names of pastel colors vary widely according to the manufacturer, we show the colors only as swatches. If you do not have these colors, most art-supply stores will offer a corresponding range.

Lemons and flower motif on teaset:

Table and Background:

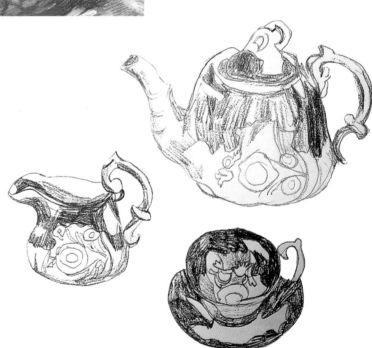

TECHNIQUES USED

Corrections	page 80
Hatching and crosshatching	page 83
Line strokes	page 84
Overlaying colors	page 85
Surface mixing	page 89
Underdrawing	page 91

1 Painting from sketches (above)
The painting brings together a series of separate elements, all of which were sketched in advance to provide a visual "reference file."
These pencil drawings, together with color studies and compositional sketches, are among those that were used to plan the painting.

2 The underdrawing (left)

Referring to her sketches, the artist begins with an underdrawing, taking care over the placing of the objects. She uses pencil for this, a method that is not usually recommended, as it can repel the pastel color. However, she intends to use the pastel thickly, and keeps the drawn lines relatively light.

3 Establishing the colors (below)

As in the Van Gogh painting, the color scheme is based on the two main complementary pairs, the main blue/yellow contrast provided by the lemons. The artist begins with these two colors, which will set the key for the rest of the painting.

4 Background colors (above)

The red/green complementary contrast, now introduced into the background, is to play a subsidiary role, but is nevertheless important in the overall color scheme. The strokes of red and green here will also form a link between the background and foreground, echoing the colors of the pattern on the teapot and cup.

5 Color balance (left)

The artist continues to move from background to foreground, with the color balance kept in mind throughout, so that the two areas are closely related. She now brings in a firm accent of blue laid over red on the lemon, making a color link with the cup and saucer in front of it.

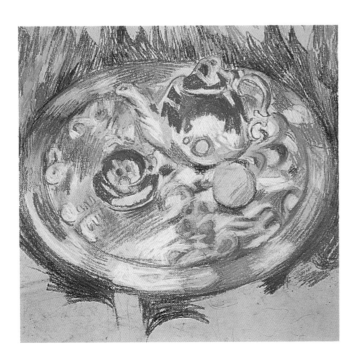

6 Making alterations (left)

At this stage in the painting, the artist decided to make a change. The lemon behind the cup was too large and overpowering, so she "painted it out" by flicking off the surplus color and then lightly rubbing down the area before laying further color. It is quite possible to make major changes like this as long as the grain of the paper is not fully filled.

7 Directional strokes (above)

The firm, energetic pastel strokes are an integral part of the composition, backing up the vivid color scheme. They also play a descriptive role. Long, curving strokes are used for the base of the table and the top edge, following the direction of the shapes.

8 Overworking (above)
The lemon removed earlier is now replaced with two smaller ones. The pastel is used thickly and heavily, so that it covers fully the colors beneath. Notice that red is again brought in to link with the background and tea service.

10 Fixing between stages (right)
The painting has now reached the stage of final color adjustments, with some colors needing to be lifted, and others to be muted or adjusted in various ways. Before working further, the painting was sprayed with fixative to avoid the subsequent colors becoming muddy and overworked.

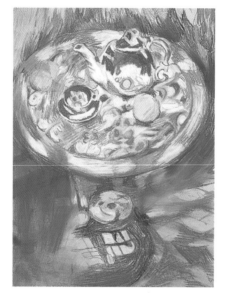

13 Final touches (right)
To strengthen the form of the teapot, subtle tonal contrasts are introduced, with a mid-toned mauve/blue laid over the darker blue and pushed well into the grain of the paper. On the area just above the artist's hand, you can see how she has mixed colors on the surface, producing a muted purple by laying red over blue.

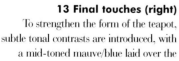

11 Leading the eye in (left)
To build up the pattern of light on the ground, the artist uses firm hatching strokes in a variety of colors, overlaying in places, but keeping the areas separate where she wants pure color. The direction of the strokes, some diagonal and others slightly curving, leads inward to the table, with the viewer's eye following them.

9 Laying a base color (above)
The strong pattern formed by the table and objects is to be repeated by a pattern of light and shade on the ground beneath it. The artist first needs a dark base color over which to work, so she lays a deep blue and blends with the side of her hand, pushing downwards so that the pastel dust falls onto the floor, rather than onto the rest of the work.

12 Sharpening up (above)
Because pastel smudges so easily, highlights often become lost in the course of a painting, and edges become soft and fuzzy. The colors can also become dull. Having sharpened up the edge of the table with white, the artist enlivens a slightly muddy area of dark blue with point strokes of deep red.

The finished picture is a lovely exercise in pattern and color, conveying a strong impression of light and atmosphere.

Viewpoint

As in the van Gogh painting, a high viewpoint has been chosen. This has allowed the artist to make the most of the pattern element, with the objects laid out on the near-circle of the table top.

Color consistency

To ensure unity of color throughout the composition, the two pairs of complementary colors are repeated in the background, where the unblended strokes create a pattern of their own.

Complementary colors

Both pairs of complementary colors appear on the tea service—red and green, and yellow and mauve-blue. The main color is blue, and the flower design is red, with a yellow center and green leaves.

Breaking the symmetry

The composition is carefully planned, with the table placed almost, but not quite, symmetrically. The symmetry is broken further by the placing of the objects, with the teapot and cup and saucer both off-center on opposite sides.

Reducing detail

If the pedestal and legs of the table had been treated in detail they would have stolen attention from the focal point; instead, the legs are merely suggested, so that they become part of the pattern of light on the ground.

Still Life with Apples and Pomegranate,
Gustave Courbet, 1871

The choice of subjects for still life is more or less unlimited, ranging from valuable objects to ordinary personal possessions, and from flowers and fruit to man-made objects such as household furniture. The Dutch still-life painters of the 17th and 18th centuries pleased their patrons by painting precious pieces of gold, lavish fabrics, or rare plant specimens, but this painting belongs to a more private tradition, where everyday objects are painted just as they are. The Dutch painters would often include fruit in their arrangements, but these were perfect,

unblemished examples, while Courbet's are shown "warts and all," just as they would be found in the marketplace.

In spite of the humble subject, the painting gives an impression of sumptuous richness and drama, deriving from the red/green complementary contrast naturally provided by the apples, and the strong tonal contrasts, with the fruit spotlighted against the dark background. Courbet's usual practice was to work from dark to light; he said that he saw himself as the equivalent of the sun lighting up a dark landscape. The other noticeable thing about the painting is the solidity of the fruit. Each one is modeled with such careful attention to the nuances of light and shade that you almost feel you could pluck them from the canvas and hold them in your hand.

EQUIVALENT COLORS

If you were to try to recreate the colors of the original painting in pastel, the following colors would be useful as a basic palette:

Background:

Fruit:

Dish:

ABOUT THE ARTIST

Gustave Courbet (1819–77) was the son of a landowning farmer in the Jura region of south-east France. Although he claimed to be self-taught, perhaps because he had a lifelong dislike of authority, he is known to have studied under various minor masters. His real artistic education, however, came from studying and copying the work of earlier masters, such as Caravaggio, Velázquez, and Rembrandt, who all claimed to paint what they saw, rather than idealizing their subjects. Courbet was to become the principal figure in the Realist school, painting contemporary subjects, rather than those drawn from history and mythology. This naturalistic approach was one that was to be taken further by the Impressionists, who admired Courbet's work, especially his landscapes, and who were beginning to make an impact on the art scene during Courbet's later life.

Still Life with Apples and Pomegranate,
by Gustave Courbet (1871)
oil on canvas,
National Gallery, London.

Shape and color contrasts
The tall shape of the tankard contrasts with the rounded forms of the fruit, and the cool, muted gray provides respite in an otherwise rich and warm color scheme.

Varying background tones
This area of mid-tone among the dense darks brings out the shape of the darker tankard and handle, which play an important part in the composition. There may have been more tonal variation in the background, but the painting has deteriorated due to the use of bitumen, an unstable pigment.

Leading the eye in
These apples overlap the pewter tankard, marking the position of the objects in space. But equally important is their compositional function, of drawing the eye into the picture toward the larger mass of fruit in the bowl.

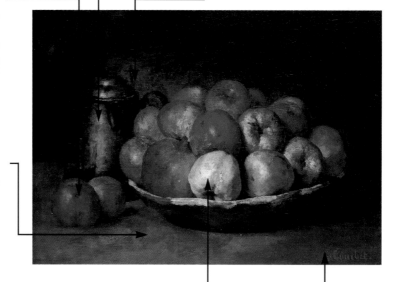

Brushwork
This potentially dull foreground area is enlivened by the swirling brushstrokes, following different directions. Similar effects can also be created in pastel, using short strokes made with the sides of the sticks (see p. 88).

POINTS TO WATCH

Take your time when you set up a still life, because it is at this stage that you do much of the composition. Remember that although the area of space you are dealing with is shallow compared with that in a landscape, you will still want to show recession, so let some objects overlap others. Avoid having too many different shapes and colors, because they may fight with one another, giving an overall impression of clutter that leaves the viewer uncertain about what to focus on. But don't leave any large areas blank, with no interest at all. If you want to stress tonal modeling, give consideration to the lighting, and try out different light sources; you may find it helpful to use a movable light. And finally, when you start to paint, bear in mind that you don't have to stick faithfully to every detail of the arrangement. Use it as a starting point, and let the painting develop in its own way.

The light source
The strong light comes from slightly to the left, behind the artist's position, creating deep shadows on the right sides of the fruit, and clear highlights slightly off-center. This "three-quarter" lighting is often used in both still life and portraiture.

The signature
Many artists regard their signature as an integral part of the painting. Here, the red balances the apples on the left, and adds interest to the immediate foreground. Another inventive use of a signature can be seen in the van Gogh painting on p. 58.

FOCUS ON SHAPE AND FORM

We recognize a shape initially by its outline, but this is no more than a convenient starting point for a drawing or painting. Real objects do not have hard lines around them, and if the outline of a rounded object is made too obvious, the shape will look flat. What we notice about the fruit in this painting is not the outlines but the volume, and this is achieved by tonal variations, and by attention to the qualities of the edges.

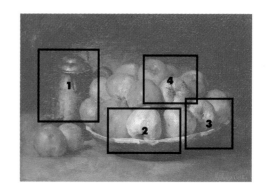

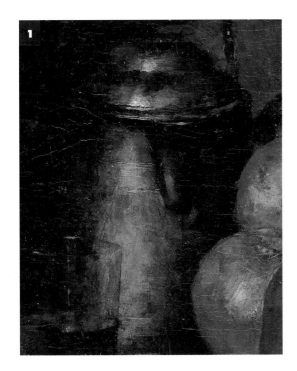

Lost and found edges (left)

Some edges will be soft and blurred, known as "lost" edges, while others will be crisp and sharp, known as "found." These are dictated partly by the shape of the object, and partly by the colors and tones. In this detail you can see a found edge on the side of the glass, and another on the rim of the pewter tankard. The edge on the left is lost, because the tone of the tankard and background are similar in value. The edges where the two fruit meet the tankard are found, because the tones are light against dark, but note that they are slightly softened, to maintain the roundness of the forms.

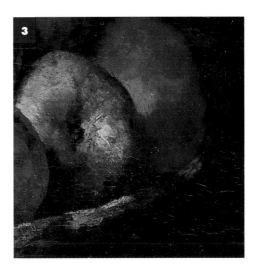

Highlights (above)

The highlights are just as important in describing the shape and form as the shadows, so give thought to their shape and placing. On the apple, the highlight has been splayed out into a thin line (probably applied with a knife), to suggest the ridged indentations where the apple curves into the stem. The highlight on the more rounded side of the red apple is softer and more diffused. Highlights are usually left until the final stages of a pastel painting, because it is easier to assess them when the other colors are in place.

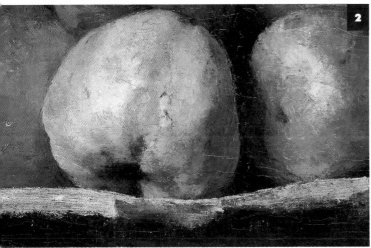

Shadow shapes (above)

If you were painting a perfect sphere, such as a ball, the gradations from light to dark would be very gentle and perfectly even. But this apple does not present a consistent curving plane; it has an indentation along the center, and is slightly flat on the right side. Notice how the dark area of tone makes a distinct shape to describe this, and the gradation from dark to light is relatively hard. On the extreme right of the green apple, you can see a thin band of lighter color running around the edge, where light has bounced off the other apple. Always look for these reflected light effects which add extra interest to the painting.

Varying the focus (left)

The triangle of green apples, with this one at the apex, is the focal point of the painting, and this has been treated in more detail than the red apples behind, which are softer and more blurred, with less tonal contrast. The partially obscured red apple at the back merges into the background, creating a sense of space and depth that aids the three-dimensional illusion.

TUTORIAL: Painting Fruit

Pastel is often thought of as best suited for delicate effects, and indeed, some artists do exploit its inherent fragility. But it is a versatile medium equally suited to a more robust approach, and Christine Russell's "Apples and Pears" shows an intensity of color and solidity of form that can rival any oil painting. She uses the pastel thickly, pushing it into the paper and blending colors by laying one on top of another—however, she also uses finger blending for small areas. She is working on the smoother side of a deep-green, Mi-Teintes paper, that has enough texture to retain the pastel and show through it a little, giving both texture and color to the fruit.

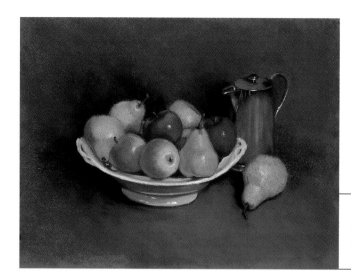

Apples and Pears, by Christine Russell

COLORS USED

Because the names of pastel colors vary widely according to the manufacturer, we show the colors only as swatches. If you do not have these colors, most art-supply stores will offer a corresponding range.

Apples:

Jug and bowl:

Background:

Pears:

TECHNIQUES USED

Blending	page 76
Details and edges	page 81
Overlaying colors	page 85
Surface mixing	page 89

1 Underdrawing (left)
Whether or not to make a preliminary drawing for a pastel painting is a matter of individual choice. In this case, the artist feels that it will help her to place the fruit and define the shapes, so she makes careful outlines with a pastel pencil in a color that contrasts with the paper.

2 Setting the tonal pitch (left)
Because the background is to be very dark, it is important to establish it at an early stage. This dark tone sets the "pitch" of the painting, and allows the artist to judge the tones of the fruit and jug against it. She lays sidestrokes of black, taking them carefully around the fruit.

3 Making color links (below)
Black has been used for the background immediately surrounding the fruit so that it will stand out well, but an all-over black would be stark and unrealistic, so olive green is laid above and around it, leaving an area of black to suggest shadows. The green will also be used on the fruit, creating a pictorial link between the focal point and the background.

4 Controlling the tones (right)
The dark-colored jug was chosen to blend into the background, not to assume equal importance with the fruit. Nevertheless, it must make sense in terms of shape and structure, so it is painted carefully, with a small band of lighter blue on the left side separating it from the background.

5 Laying a base color (above)
With the background and jug in place, the artist can now begin on the fruit. For the pears, she uses an all-over base color of mid-toned olive green, to which she will add darker and lighter greens to define the forms as the painting progresses.

6 Avoiding heavy pressure (above)
Before bringing in the rich reds and oranges of the apples at the front of the bowl, the pears have been partially modeled with the dark green used for the background, and a deep, purplish red base color is laid over the other apples. The artist is still working fairly lightly, avoiding over-filling the grain of the paper so that she can overlay further colors as needed.

7 Overlaying colors (right)
The shapes of the fruit and the basic colors are now well established, but the forms are not yet fully three-dimensional, so she begins to lay colors more thickly over one another to build up both shadows and highlights. Notice that on the foreground, light-colored apple she has used a touch of cool blue-gray on the dark band of shadow.

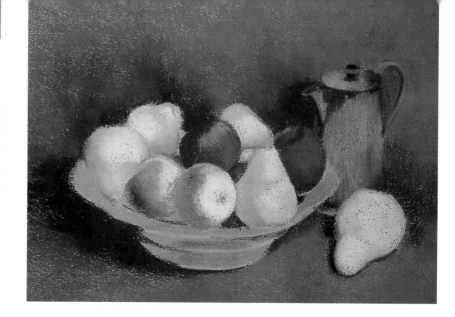

8 Assessment (right)

The painting is now approximately at the half-way stage, with the paper fully covered, but further definition still needs to be done. Most artists find it helpful to take a short break at this stage, standing back from the painting to look at it critically and decide how much remains to be done.

9 Textural contrast (left)

The jug was rather amorphous, so further work is done to bring out the reflective qualities of the metal surface, that contrasts with the soft, matte surfaces of the pears. After adding lighter grays on the body and handle, a sharp edge of white pastel is used to produce small, crisp highlights.

10 Dragging colors (right)

To soften the gradation between light and dark tones on the apple, and to add a touch of texture, a stick of pastel held on its side is dragged lightly over the earlier colors so that it catches on the grain of the paper.

11 Keeping the whites clean (above)

The white bowl has been left until last; if it had been painted before the fruit were finished, the colored pastel dust might have dropped down and dirtied the white. A mid-toned gray, the color of the shadowed areas, is painted over the whole area first.

12 White over gray (above)

White has been laid over the gray on the rim of the bowl, and highlights are added to the foot. Working over the gray has produced has produced exactly the right tone; the bowl is not pure white, though it "reads" as white in the context of the painting as a whole.

The finished picture is full of life and color, with the fruit glowing against the dark background, and the forms solidly modeled. The contrast of textures, often an important theme in still-life painting, adds an extra dimension.

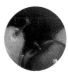

Spatial relationships
Although the area of space in a still life is small compared to that in a landscape, it is still important to define it, and the position of objects within it. The dark shadow area behind and to the side of the bowl of fruit helps to do this, pushing the background back.

Arranging the fruit
The artist has taken time arranging the fruit so that, although some overlap, they do not obscure one another completely, and their shapes can be seen clearly. The central group of three apples makes a pyramid shape that echoes that of the upright pear on the right.

Reflective surfaces
Metallic surfaces reflect more light than matte ones, giving sharp highlights and clear edges between dark and light tones. These have been observed and placed with care so that they define the shape, as well as explaining the type of surface.

Overlapping
Overlapping objects also creates the illusion of depth, because we know that one is in front of another. Here, there is an additional reason, because the pear contrasts well with the jug in terms of both color and texture.

73

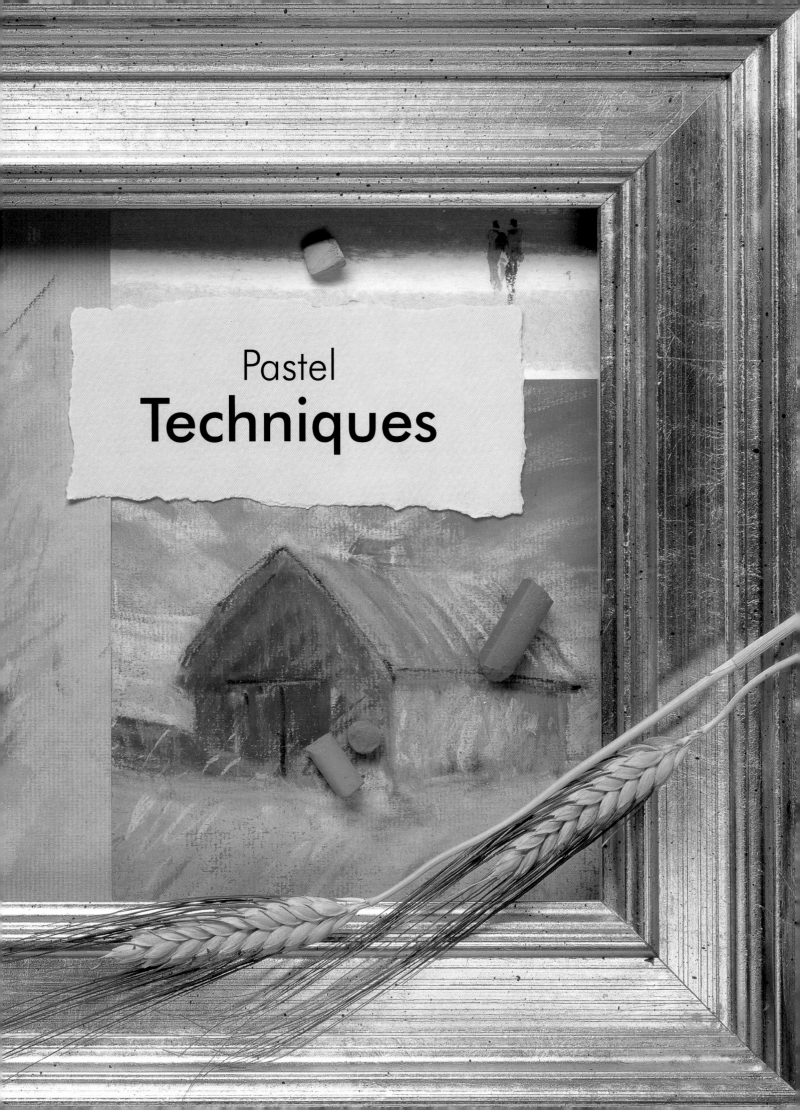

Pastel
Techniques

Pastel Techniques

This section, illustrated with easy-to-follow step-by-step demonstrations, focuses on ways of working in pastel, from basic techniques such as blending and building up colors to more unusual techniques such as working over an underpainting and laying special grounds.

BLENDING

Because pastel is such a soft, crumbly medium, it is easy to rub colors together to achieve soft blends or passages of evenly gradated tone. This was one of the characteristics of the medium much prized by the 18th-century portrait painters who worked in pastel, for whom the linear element in pastel work was seen as undesirable. Some of today's pastellists still make extensive use of blending, producing highly finished, carefully controlled work, but the majority take a looser, freer approach, exploiting the marks of the pastel sticks for their individual expressive qualities.

An overblended work can appear rather dull and bland, and there is a danger that too much surface mixing (see p. 89) can muddy the colors, but blending is still an important technique in pastel work, even if used only in certain areas, or for the early stages of a painting. For example, the main colors of a landscape might be blocked in with side strokes (see p. 88) that are then loosely blended and worked over with other colors; alternatively, touches of blending could be done in the final stages of a painting, perhaps to soften and blur the colors in a background, or areas of the face in a portrait.

Various implements can be used for blending, depending on the size of the area. For a sky, you can use a rag, a large brush, or the flat of your hand, while for small areas you can blend with the tip of a finger, a cotton swab, or a special tool made for the purpose, called a paper stump or torchon.

Mixing colors

You will often want soft gradations of colors and subtle mixes. Lay down two colors one over another, and rub them together with a finger or paper stump (torchon).

Soft pastel skies

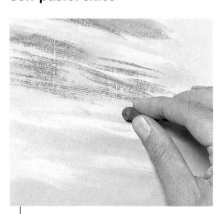

1 To blend two colors into one another partially, as for clouds, lay down light strokes of your chosen colors, creating a series of bands.

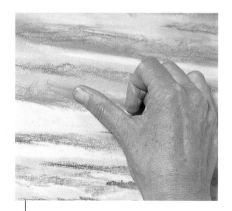

2 Use your finger or thumb to rub them gently together and soften the pastel strokes. Blend in the same direction as the strokes.

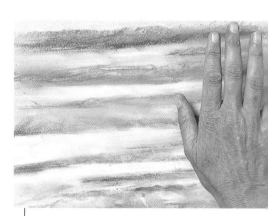

3 Introduce further colors as needed, and blend in the same way, or leave parts of the final layer unblended if you prefer.

Oil pastel

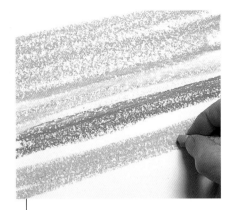

1 Oil pastel cannot be blended with fingers or implements, but you can blend by melting the color with mineral spirits (white spirit). First lay the colors on dry as for soft pastel.

2 Dip a rag or brush in the spirits and wipe it over the area to be blended. You can also produce mixtures in this way, laying two colors over each other and working them together.

BROKEN COLOR

This is a term used to describe an uneven layer of color that is laid on deliberately so that it only partially covers the surface and allows colors beneath to show through. A sky, for example, might be built up with short, light side strokes (see p. 88) of various blues and mauves laid over one another but left unblended, giving a much more vibrant color effect than flat, blended color. Line strokes (see p. 84) can also be used to create broken-color effects, with a network of different colors laid over one another, either in a controlled way by hatching and crosshatching (see p. 83), or more randomly.

The aim is to create a coherent, but lively, area of color that reads as one color when viewed from a distance—the method is sometimes called optical mixing, because the colors mix in the eye. The colors must be close in tone, as a juxtaposition of lights and darks will be jumpy and incoherent.

Patterns—Morning in September,
by Simie Maryles
The artist has used broken color to emphasize the pattern element of the scene. Notice how she has woven red into the greens of the tree.

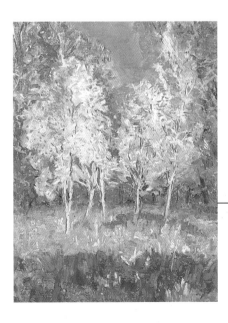

1 Short lengths of pastel are used to build up the whole surface with varied small strokes in a variety of colors.

2 This method is ideal for foliage, as it gives an impression of light and movement that you can seldom achieve with flat, blended color.

CHARCOAL AND PASTEL

Charcoal is often used for the underdrawing (see p. 91) for a pastel work, but it can play a more significant role, being used in partnership with pastel so that both have a part in the finished appearance. Charcoal and pastel have similar textures and handling properties, so charcoal lines blend in well with the pastel color. It is particularly useful for linear drawing in a portrait, where it can be used over lightly applied and blended color, or for touches of definition in a landscape, such as tree branches. Charcoal is less dense and black than black pastel, and gives a lighter, more subtle effect.

Another use of charcoal is to make a full-scale tonal underdrawing, rather than the more usual linear one restricted to outlines. This method is not suitable for a "high-key" painting, in which the colors must be kept clear and light, but is well-suited to a more somber color scheme or a painting with a predominance of dark and middle tones.

East Foothills,
by Claire Schroeven Verbiest
The bold choice of a vivid red ground has given warmth and richness to the whole color scheme. The greens have been applied very lightly, so that the ground color shows through.

1 The artist begins with the charcoal, making a full drawing in both line and tone, but leaving areas that are to be vivid in color free of charcoal.

2 She now blocks in the brightest and lightest colors, mixing as needed. Here, blue is laid over green to achieve the vibrant hue of the shed wall.

3 She continues to build up the colors and tones, laying pastel over the charcoal for areas of muted color and drawing into it with more charcoal.

COLORED GROUNDS

As mentioned in the first chapter, pastel paintings are usually done on colored rather than white paper. Pastel does not cover the paper completely unless applied very heavily; it sits on the raised grain so that the paper shows through the strokes. Flecks of white create a jumpy effect, as well as making it difficult to judge the values of the first colors laid on, so a mid-toned paper is usually chosen, enabling you to work up to the light tones and down to the dark tones.

Because large ranges of grounds are available, it can be difficult to decide on the most suitable. Exciting effects can be achieved by working on very dark papers, even black, but in general it is best to avoid vivid reds and blues that may fight with the applied colors. Good all-round choices are grays, blue-grays, beiges, and warm creams. Some pastellists choose a warm paper color for a painting with a cool color scheme, because this provides an element of contrast, while others choose one that tones in, such as blue-gray for a seascape. If you have any special color requirements that cannot be met by any of the standard ranges of pastel paper, you can lay your own colored ground on watercolor paper, using either watercolor or thinned acrylic (see also underpainting, p. 92).

2 **Warm beige paper**
The crimson has less impact on this paper, but interestingly, the warm background color makes the crimson itself appear cooler.

3 **Black paper**
Because there is such a strong tonal contrast, this creates a powerful and dramatic effect. It is worth experimenting with dark papers.

1 **Cool blue-gray paper**
These three examples show how the paper color affects the pastel colors. This cool gray shows up the crimson, making it look very vivid by contrast.

CORRECTIONS

Although pastel is suitable for both linear drawing and full-color painting, it is easier to make corrections in the painting "mode." Firmly drawn point strokes cannot be erased as cleanly as can pencil or charcoal ones, though you can partially remove them with a kneaded eraser, and if the lines are not too heavy, they may come out successfully. (Never use an ordinary eraser for pastel work, because this will simply push the color into the paper.) The type of paper is another factor; for example, pastel adheres less strongly to standard pastel papers than to sandpaper or pastel board, so is easier to remove.

If you are building up a painting in layers (see overlaying colors, p. 85), you can make corrections at more or less any stage in the work, simply by working over the area with further colors. Because pastel is an opaque medium, the new colors will cover the earlier ones, provided there is not already a thick build-up of pigment. If you find a light color will not cover a darker one without muddying, this means that you have already filled the grain of the paper, and you will have to remove some color before working further. This can be done by flicking it off with a stiff brush and then, if necessary, wiping down the area with a rag.

Oil pastel

Because of the greasy texture of oil pastel, that makes it cling to the paper, it is more or less impossible to erase drawn lines, but you can, to some extent, make corrections by overworking, again providing that the paper grain is not fully filled. If this has happened, it is possible to remove earlier layers of color by gently wiping with a rag soaked in mineral spirits (white spirit), or for small areas, scrubbing the color off with a brush. You will be left with a stain on the paper, but this does not matter, because it will be covered by the new colors.

If pastel color has not been too heavily applied, it can be lifted off with a kneaded eraser. Take care not to rub the color into the surface.

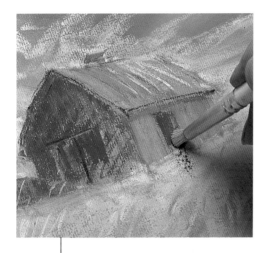

1 The artist has decided that the dark door is too obtrusive, so he flicks off the color with a stiff brush.

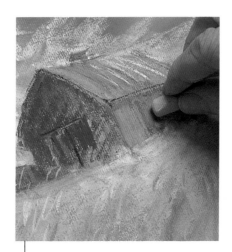

2 He then works new colors firmly over the corrected area. If you want to add further layers of colors, it is sometimes necessary to spray with fixative first.

3 He continues to build up the colors. There is now a good deal of pastel on the surface, and dust has collected at the bottom of the strokes, so he picks this up with a kneaded eraser.

Still Life with Natural and Man-made Objects,
by Paul Bartlett
This painting shows how soft pastel can be used to create very precise effects and clean edges. The artist has used a variety of masking methods.

DETAILS AND EDGES

Although pastel is such a soft, crumbly medium, you can achieve a surprising amount of detail, as well as clear, crisp edges, if you work methodically and plan your effects. Small details, such as points of light on leaves and grasses in a landscape, or highlights in a still life or portrait, should always be left until last, otherwise there is a danger of smudging them. A useful aid at this stage in a painting is a maulstick (or mahlstick)—you can make one yourself by wrapping some rag around one end of a piece of garden cane or dowel. You rest the padded end on the top of the drawing board, preferably outside the margins of the painting, and then rest the wrist of your working hand on the stick. This keeps your hand steady, so that you can place the details accurately, and also keeps your hand away from the work.

To produce sharp, straight edges, such as those that mark the division of planes in an architectural subject, a simple method is to hold the straight edge of a piece of spare paper along this line and work the pastel right up to it. This is best done in the early stages of a painting, otherwise you may smudge existing colors; the edge can be reinforced later if further colors have slipped over it. For a more complex shape, such as a vase or bottle in a still life, a method sometimes used is to cut a mask from tracing paper and hold it in place while you fill in the shape. The background around the object should be completed first or left as the paper color, because you may spoil the edges if you work any further on it. But remember that the edges of an object are not uniformly hard and clear, so you may want to soften them in places by blending into the background color.

Left: a clean, straight edge can be produced by working against a piece of paper. Remove the paper carefully to avoid smudging.

1 To make a mask for a shape, it is drawn out on tracing paper and cut out; the remaining paper is the mask.

2 The apple and background are painted an overall color, then the mask is put in place to complete the green areas of the apple.

3 When the mask is removed, the edges are crisp and well defined. You can make them softer by using less pressure on the pastel stick.

FEATHERING

This is a technique in which the tip of the pastel stick is used to lay light, linear strokes over another color. It is useful for building up broken color effects (see p. 77) and for making modifications. A color that looks too bright can be "knocked back" by feathering with a more muted color, or with the complementary color—green over red, for example. Feathering can also be a remedial measure. Unpracticed pastel painters often over-blend in an effort to achieve a color that precisely matches the subject, and this can result in flat, featureless areas where the texture of the pastel has been lost. These can be enlivened and enriched by feathering one or more colors on top, spraying with fixative first if the grain of the paper is too full to take further applications.

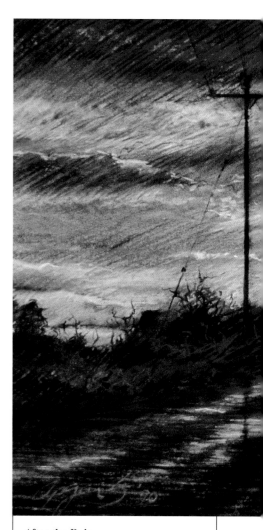

1 The picture was blocked in with side strokes, laid relatively flat, and colors were then feathered on top. Because two pairs of complementary colors—red and green, and yellow and mauve—have been used, the effect is very vivid.

After the Rain,
by Elizabeth Apgar Smith
Effective use has been made of diagonal hatching strokes for the sky, and horizontal ones for the land area.

In this area, you can see three separate layers of feathered strokes, light yellow, deep yellow, and mauve, with a little of the base paper color still showing through. **2**

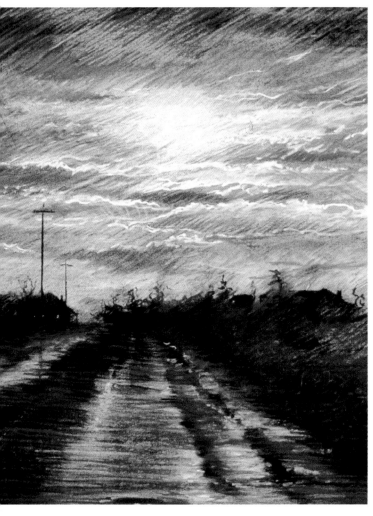

HATCHING AND CROSSHATCHING

These methods were originally a method of building up tones in drawings, using a point medium such as pen-and-ink. In hatching, a series of separate and roughly parallel strokes are laid next to one another, and in crosshatching, a further set of strokes crosses the first at or near a right angle. For middle and light tones, the strokes can be light and widely spaced, becoming denser for the darker areas.

Although the method was first developed for monochrome work, it also forms a means of color mixing (see surface mixing, p. 89), because a variety of colors can be used in any one passage of the painting. Degas made use of hatched lines in many of his pastel works, and in some contemporary pastels you can see an adaptation of the technique, often used quite loosely, using broad strokes made with the blunted tip of a pastel stick. The lines need not be uniform, either in thickness or direction—you might lay thin cross-hatching lines over thicker, more widely spaced hatching, and use upright strokes to describe flat planes, and curving strokes for more rounded forms.

1 This rendering shows how varied hatching and crosshatching strokes can be. In the foreground they are roughly diagonal, and have been softened in the shadow area by blending with a finger. Farther up, they curve around the side of the bowl.

2 Here, a network of delicate hatching strokes has been made over solidly applied color with the point of the pastel stick. The primary purpose of these strokes is to ensure consistency of technique throughout the picture.

LINE STROKES

Although many pastel painters today use the medium to create broad, paint-like effects, pastel is basically a linear medium, allowing you to exploit the marks made with the point of the stick. These marks can be widely varied, depending on the softness of the pastel (some ranges are softer than others), the shape of the stick, the sharpness of the point, and the pressure applied. Using the edge of a square-sectioned, hard pastel stick will give a very fine, sharp line, while marks made with the tip of a soft pastel will be thicker and less crisp. It is worth trying out different types of pastel to discover their capabilities, and practicing different linear strokes, from fine, straight lines to curves and squiggles, or strokes in which you vary the pressure from one end to the other.

Some pastellists build up whole paintings with a network of linear strokes, while others combine line and side strokes, sometimes starting with the latter to block in the colors and then working over them with linear marks, or using line to accentuate certain areas. Any lines that appear too hard and over-obtrusive can be softened by gently rubbing with a finger.

Firm strokes with blunt point of stick.

Free, squiggling lines with large pastel stick.

Pointed strokes are achieved by reducing pressure on the pastel stick as you draw.

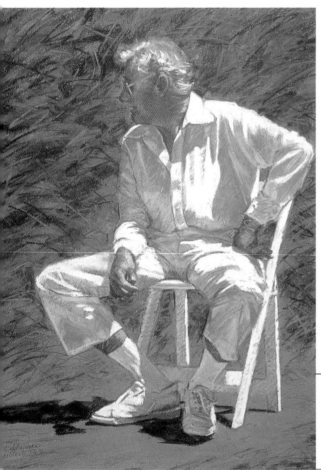

Man in Sunlight,
by Claire Schroeven Verbiest
Sharp but delicate line strokes
worked over side strokes gives a
lively feel to the image.

Random scribbles with a lightly held pastel can be useful for shading and textured effects.

Varying pressure of strokes on rough paper, from heavy to very light, gives broken effects.

Layering different colors to produce mixtures is on of the most effective pastel techniques.

OVERLAYING COLORS

Laying one color over another is the only way to produce mixtures in pastel work (see surface mixing, p. 89), but overlaying is more than just a practical method. The way colors can be built up in varying densities so that one shows through another is one of the most exciting aspects of pastel work. Scumbling (see p. 86) is one form of color overlay, and hatching and crosshatching another pair (see p. 83), but you can also use side strokes to drift colors lightly over one another, making a series of veils that enrich or modify the colors beneath. The effectiveness of this method can be seen in the demonstration on pages 22–25.

For the technique to be successful, it is important to work methodically, beginning with light strokes that do not overfill the grain of the paper, and working up the depth of color gradually. You may need to fix the work in stages, to hold each layer in place before adding another. It is vital to consider the way the colors will work together, so if you are uncertain of, for example, how a warm blue will look worked over a cooler, greener blue, try it out on a spare piece of paper first; until you are familiar with color relationships, it is easy to make mistakes and either change or deaden the original color.

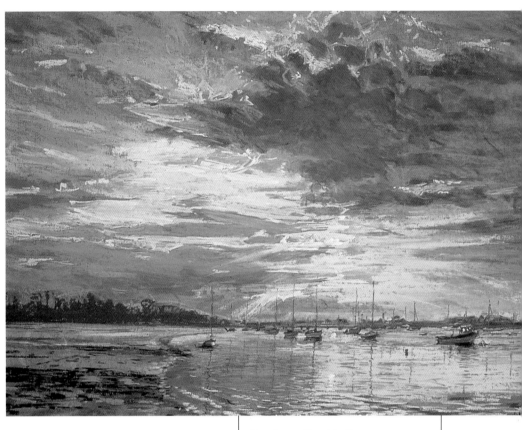

Sundown, Rambholt,
by Margaret Glass
The artist has worked on sandpaper, layering one color over another to achieve a wonderful painterly effect.

1 The main colors have been established with light side strokes, and the work is sprayed with fixative to hold the color in place during the subsequent stages.

2 Further colors are built up, with the strokes becoming heavier and more positive.

3 The artist does not try to cover the original colors entirely, but to build up a network of strokes, some laid over earlier colors, some interweaving and crossing them.

SCUMBLING

This is a technique common to all the opaque painting media, in which one or more colors are applied over one another in light veils, so that each one only partially covers the one below. You may find that you use the method naturally in pastel, without really thinking about it, because pastel seldom covers the paper, or an earlier color, completely, unless it is used very heavily.

Scumbling can be done either with short, light, straight side strokes (see p. 88), or with a circular motion of the pastel stick. It is a method often used for skies, or to enliven large areas of background in a portrait, still life, or flower painting, because the effect of the colors showing through one another is more exciting than flat, blended color. You can scumble light over dark or vice versa, but if you want to achieve a color that appears homogeneous when viewed from a distance, that is, one that "reads" as one color, avoid tonal contrasts. In a sky, for example, you might use a variety of different blues, mauves, and blue-grays of the same value. Scintillating effects can be created by scumbling versions of all three primary colors over one another, or by combining complementary colors, such as green over red, or yellow over light mauve.

1 Scumbling is essentially a free, broad technique, but it can be controlled quite precisely. Here, it is used for a cloud effect.

Scumbling oil pastel

1 Scumbling is a useful method for color mixing in oil pastel because it cannot be blended as easily as soft pastels. Here, reds, blues, and mauves have been scumbled over one another.

2 A selection of light-toned colors are scumbled over one another, with side strokes following different directions. The effect is both attractive and realistic.

In this example, reminiscent of foliage, **2** greens and blues have been scumbled over light yellow with a roughly circular motion of the pastel stick, much like scribbling.

SGRAFFITO

This technique, of scratching into one layer of color to reveal another beneath, can to some extent be done with soft pastels, but is much more successful with oil pastels, because these adhere more strongly to the paper. It is essential to lay the first color heavily so that it fills the whole grain of the paper, and the second layer thickly enough to cover the first. For the scratching you need a sharp implement, such as a craft knife.

To achieve a good effect, the colors must be worked out in advance so that you have sufficient color and tone contrast to make an impact. You might even use the complementary colors, laying red over green, or using a layer of yellow beneath mauve, and scratching into it to create a linear pattern. This could work well in a still life featuring patterned fabrics or ceramic objects. In a landscape, you might begin with yellow overlaid with dark green, and use the method to reveal the yellow in highlighted areas of foliage or of grasses.

Another way of using the method is to paint the first color with acrylic or colored inks, using oil pastel for the second and any subsequent layers—you are not restricted to two-color effects.

1 After making a drawing, the artist lays on the oil pastel thickly, starting with the dark purple, which she intends to scratch into.

2 She has added further colors to build up the form, but relies on the sgraffito to provide the sharp definition, using the point of a knife to make fine lines.

3 In this area, several colors have been layered over one another, and the knife is used to scratch away the top layers. The surface is a heavy watercolor paper, thick enough to withstand this treatment.

SIDE STROKES

When you use the point of a pastel stick you are basically in drawing "mode," whereas using the side of the stick is more akin to laying on paint with a brush. These are the strokes to use when covering large areas in the initial stages of a painting, and for building up in a series of layers. In a layered and heavily blended work, the individual strokes may be scarcely visible, but if left as they are or only partially blended, side strokes can be as expressive as line strokes (see p. 84), and as widely varied, depending on direction and degree of pressure.

Another factor is the length of the pastel stick used for the strokes. It is seldom possible to make line strokes with a whole stick of pastel, because it will break, so side strokes are normally made with a stick broken in half, which gives a broad mark. But very short pieces can be used to make more decisive, jabbing strokes that begin to resemble those made with the point. Newcomers to pastel often dislike breaking the sticks, but it does not matter, indeed it can be an advantage, as a box full of half- and quarter-lengths and tiny fragments will force you to vary your strokes, just like the use of different brushes when painting.

Side and line strokes can, of course, be combined, and in the majority of pastel paintings you will see the two used together.

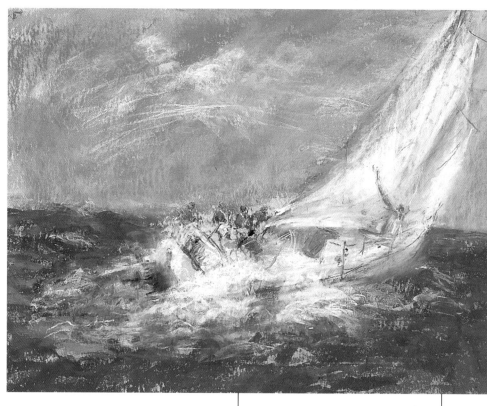

Freshening Breeze,
by Constance Harford
A lovely feeling of movement is conveyed through the ingenious use of the medium, with the strokes varying from long sweeps to short curves that describe the turbulent water. In places, fine line strokes have been laid on top to sharpen the focus.

1 This picture is to be built up entirely in side strokes. The artist begins with long horizontals, laying a pale blue over a darker one at the bottom of the sky.

2 For the sunburst, which is the picture's focal point, he uses directional curving strokes, crossing the original strokes.

3 To indicate the way the light falls on the trees, and create strong tonal contrasts, yellow was laid on first, followed by short, diagonal strokes of mid-tones and light green.

SURFACE MIXING

Paints can be mixed to the correct color in a palette before being applied to the surface, but pastel colors can only be mixed on the paper itself. Even if you have an extensive range of pastel colors, some surface mixing is nearly always necessary, because the range of colors and tones in nature is so vast.

The principle of surface mixing is very simple; it involves no more than laying one color over another. But different effects can be achieved according to whether you rub the colors together (see blending, p. 76) or leave them unblended. Blending will achieve a thorough, homogeneous mix, for example, yellow laid over blue and blended will produce green. But if you lay yellow over blue without blending, both colors will still be visible while giving an overall impression of green. In any painting you can combine blended and unblended color mixes as the subject demands. In a landscape, for example, you might want a deep, solid area of mauve-blue for the sky, but a lighter, broken-color effect for trees or grass, with line strokes (see p. 84) or side strokes (see p. 88) of yellows, blues, and greens laid over one another in varying quantities and left unblended. In a portrait you might blend only the skin colors, contrasting this soft, gentle effect with a more dynamic treatment of hair and clothing.

Mixing with three colors

1 The base color is a deep, warm blue, with two shades of pale violet laid on top and lightly blended.

2 The same blue with a pale turquoise and a light pinkish-violet laid on top. Again, the colors are only lightly blended, so that they all retain their identities.

Mixing with two colors

1 Side strokes of yellow laid over blue to produce a lively green, more visually exciting than a ready-made green.

Fall on the Flatland,
by Doug Dawson
The subtle but rich colors have all been achieved by surface mixing, with the red ground allowed to show through to provide a further color.

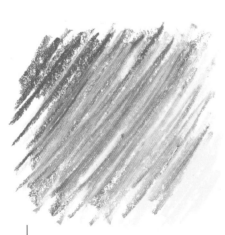

2 Line strokes of the same two colors, left unblended. The colors do not mix as thoroughly, but give the impression of green when viewed from a distance.

TEXTURED GROUNDS

All pastel papers have some texture, because this is necessary for holding the pigment in place, and there are various different ones to choose from. But some artists, mainly those who like to apply the pastel thickly and heavily, make their own grounds to individual recipes. A surface rather like that of artist's sandpaper (which is not always easy to obtain) can be made by scattering pumice powder onto masonite (hardboard) or mat (mount) board. You will need to lay a coat of adhesive first; this could either be glue size, wallpaper paste, or acrylic medium. When the surface has dried out, it can be colored with thinned acrylic or watercolor.

A substance called acrylic gesso is also popular for texturing grounds. This is thick enough to hold the marks of a brush, and if you lay it on with a large bristle brush or household brush, you can create a pattern of slightly raised ridges on which the pastel color will catch. The direction of the brushmarks can follow the direction of the pastel marks, or oppose them to create a raised crosshatching effect. Gesso grounds can be colored, either by mixing acrylic paint with the gesso before painting it on, or by tinting it afterwards. These grounds are not suitable for small-scale, heavily blended, or highly detailed work, because the underlying texture breaks up the pastel strokes, but they are effective for broader, more robust approaches.

Doris and Tom's Sycamore,
by Claire Schroeven Verbiest
The artist has worked on a special
type of sanded paper, which has a
finer surface than acrylic gesso on
watercolor paper, but holds pastels
well, allowing for layering of color.

1 Acrylic gesso, tinted with color, is painted loosely over the surface of watercolor paper. If a more vivid ground color is required, it can be put on as a second stage, when the gesso is dry.

2 The texture of the ground will break up the pastel strokes, so fine lines are not possible. Instead, the artist aims for a broad effect.

UNDERDRAWING

It is not strictly necessary to make a monochrome underdrawing for pastel work. Because pastel is both a drawing and a painting medium, you can make a guideline drawing using one or more of the colors you see in the subject. But some artists prefer to make a more detailed drawing, which is a way to plan the composition and to make sure that the elements are correctly placed and in the right proportion to one another.

Pencil should never be used for the preliminary drawing, because graphite is slightly greasy and repels the soft pastel pigment. Monochrome outline drawings can be made with pastel pencil, hard pastel, or charcoal. The advantage of charcoal is that it can be easily rubbed off the surface so that you can continue to make amendments until the drawing is satisfactory; pastel lines, on the other hand, cannot easily be erased.

Excess charcoal should be flicked off the surface before laying on the colors, to prevent it from polluting them, or alternatively, the drawing can be sprayed with fixative.

Charcoal underdrawing

1 The advantage of charcoal is that you can make corrections simply by brushing it off the surface. The paper may be slightly discolored, but not enough to compromise the pastel color.

If you are worried that the charcoal lines **2** are too heavy, brush down the surface with a soft brush, and then spray with fixative to hold the remaining charcoal in place.

Pastel pen underdrawing

1 Pastel pencil is less forgiving than charcoal because it is less easy to erase, so do your best to be accurate from the start, and choose a color that will blend in with those of the subject.

2 Concentrate on outline, avoiding shading, and strengthen the lines only in places that will be dark in the painting, such as the bottoms of the fruit and plate here. If you make heavy lines in light-colored areas, you may not be able to cover them.

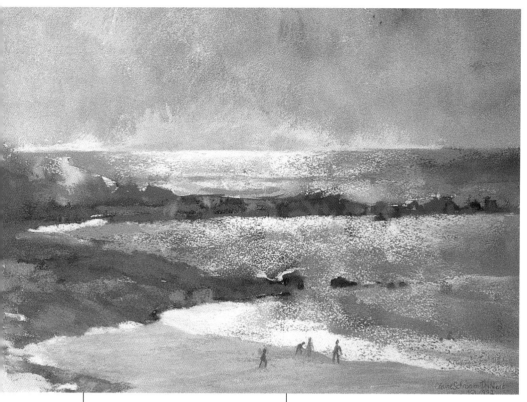

Sunglade,
by Claire Schroeven Verbiest
This lovely painting has been
worked with soft pastel over
watercolor, which is still visible in
the sky area and the rocks at left.

UNDERPAINTING

To begin a pastel painting, it is common practice to block in the main shapes and colors with light side strokes (see p. 88), and gradually build up with further layers of color, but an alternative method is to work over an underpainting, made in acrylic or watercolor. This can be mono-chromatic, in which case it serves the purpose of establishing the tonal structure of the picture (see charcoal and pastel, p. 78), but more often it is in color, and resembles a light color sketch.

The advantage of this method is that it allows you to cover the paper quickly, so that you can complete the painting with fewer layers of pastel color, allowing areas of the underpainting to show through. Some artists use similar colors for the underpainting as for the final work, while others exploit contrasts, painting yellow on an area that is to be blue-gray, or using red under green for a sparkling complementary contrast of colors.

Standard pastel papers are quite thin, and will not accept water without buckling; water will spoil the surface of pastel board or sandpaper, so watercolor paper is the best choice for this method.

1 Here, transparent, well-diluted acrylic has been chosen for the underpainting. If acrylic is used too thickly, it seals the paper and forms a skin, so that there is no tooth to hold the pastel color.

2 The secret of success with this method is to follow a consistent working method for both paint and pastel. The artist plans to emphasize diagonal strokes, and her brushwork follows the same style.

3 When she begins to use the pastel, she keeps the strokes fairly light, not attempting to cover the acrylic colors beneath.

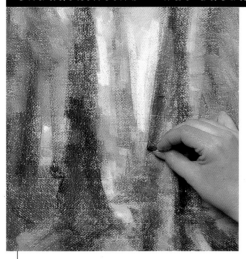

WET BRUSHING

This is a technique in which the color is applied in dry form to the paper and then spread out with a wet brush. Adding water to soft pastel turns it into a form of paste that quickly fills the grain of the paper, so this is a quick way of covering the surface. The water also acts as a fixative, enabling you to layer further colors on top, either with dry pastel or further wet brushing. Degas is believed to have used a form of this method to achieve the remarkable depth of color in his pastels.

The extent to which the pastel color can be spread depends on the type of brush used. A bristle brush, used with fairly heavy pressure, leaves little of the original line visible, but a soft watercolor brush will take the color only from the top of the paper's grain, so that the character of the pastel strokes is retained. This approach can be used to soften lines and model forms in, for example, a portrait or figure painting.

The same method can be used for oil pastel, but in this case the medium used to spread the color is turpentine or mineral spirits (white spirit). Oil pastel, being thick and greasy, tends to clog the surface more rapidly than soft pastel, so it is best to begin by applying the color fairly lightly. Over-thick areas can, however, be wiped off with a rag dipped in mineral spirits.

1 To successfully employ the wet-brushing method, it is best to begin broadly, using side strokes to establish the composition and color scheme.

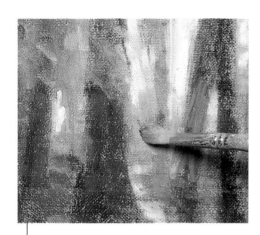

2 She now dips a bristle brush in clean water and begins to spread the color, taking care that her brushstrokes follow the pastel marks.

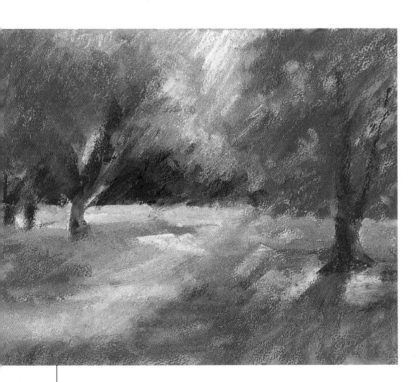

4 The effect of layering pastel colors over the paint gives the picture a lovely shimmering quality, with colors showing through one another to produce rich optical mixtures.

To build up the form of the tree **3** trunk, she lays black pastel on one side, and spreads it as before, having first washed the brush to remove any traces of the light color.

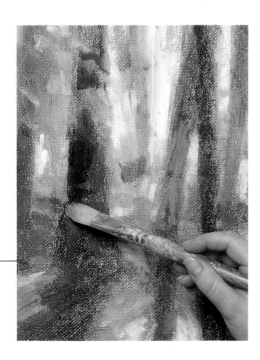

Index

Illustrations of completed pictures are indicated by *italics*. Where these are part of a tutorial the reference includes '+ SSD' (Step-by-Step demonstration). SSD in parentheses following a page reference indicates a Step-by-Step demonstration of a technique.

Credits

Quarto would like to acknowledge and thank the following for pictures appearing on the pages given below

AKG, London: 34-5, 50-1; Christie's Images: 10 r; National Gallery, London: 26-7.

Key: l = left r = right

All other pictures are the copyright of Quarto

Quarto would also like to thank the many artists who have contributed their work to this book, and in particular the following artists who performed the step-by-step tutorials:

Steven Bewsher
Pip Carpenter
Sharon Finmark
Margaret Glass
Debra Manifold
Christine Russell